MASACCIO

*Saint Andrew*
and *The Pisa Altarpiece*

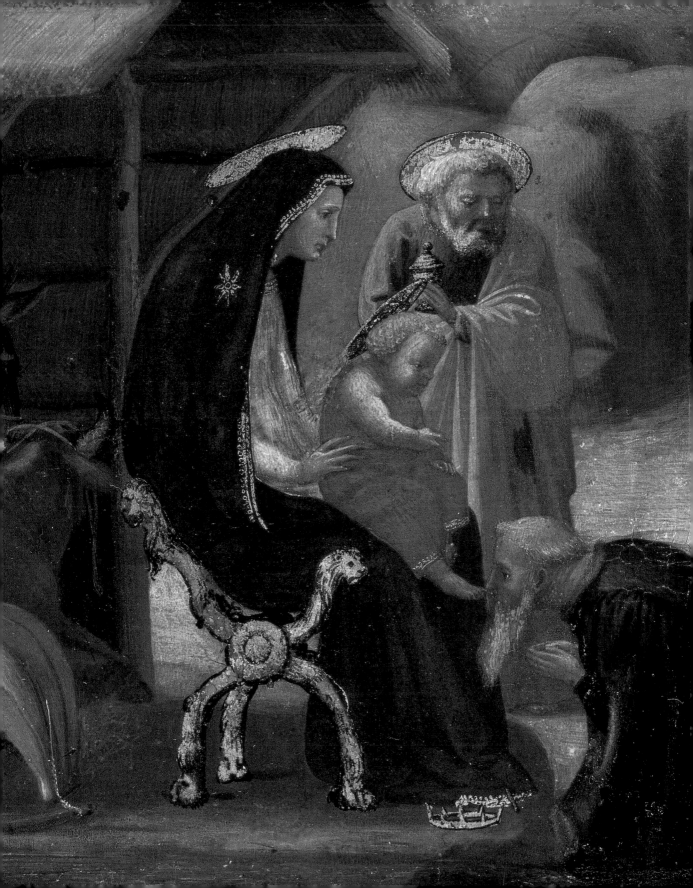

# MASACCIO

# Saint Andrew and
# The Pisa Altarpiece

Eliot W. Rowlands

GETTY MUSEUM STUDIES ON ART
Los Angeles

*To my beloved son, Andrew*

Getty Publications
1200 Getty Center Drive, Suite 500
Los Angeles, California 90049-1682
www.getty.edu

Christopher Hudson, *Publisher*
Mark Greenberg, *Editor in Chief*

Mollie Holtman and Tobi Kaplan, *Editors*
Diane Mark-Walker, *Copy Editor*
Jeffrey Cohen, *Designer*
Suzanne Watson, *Production Coordinator*
Anthony Peres, *Photographer*
Dusty Deyo, *Illustrator*

Typeset by G & S Typesetters, Inc.,
   Austin, Texas
Printed in Hong Kong by Imago

Library of Congress Control Number:
2003102523
ISBN 0-89236-286-3

*Cover:*
Masaccio (Tommaso di Ser Giovanni di Mone Cassai; Italian, 1401-1428). *Saint Andrew* [detail], 1426. Tempera and gold leaf on panel, 46.1 × 30.2 cm (18 ⅛ × 11 ⅞ in.). Los Angeles, J. Paul Getty Museum (79.PB.61).

*Frontispiece:*
Masaccio, *The Adoration of the Magi,* 1426 [detail]. (See Figure 30.)

# CONTENTS

*See the foldout and key at the back of the book for the author's proposed reconstruction of the Pisa Altarpiece*

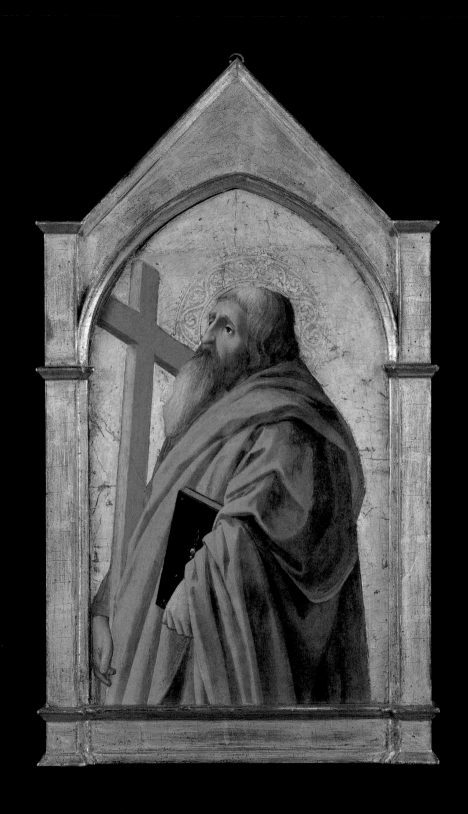

# INTRODUCTION

In 1979 the J. Paul Getty Museum acquired one of the rarest of pictures, a panel painting in tempera and gold leaf by the Florentine Renaissance master Masaccio [FIGURE 1]. Its subject, the apostle Saint Andrew, stands in three-quarter-length format, his voluminously draped body turned in profile toward a strong, unseen light source at the left. The saint's form consists of a simple silhouette set against a gold-leaf background and interrupted only by the insertion of a wooden cross at the left. This, the identifying attribute of the apostle (he was crucified on an X-shaped cross), and a dark book tucked along the inside of his left forearm are set in perspective, with diagonals leading up toward the left. The saint's gaze—one sad, droopy eye is visible, set in a deep, arched socket—follows in the same direction. His only other visible facial feature, an unusually long, craggy nose, leads on to a foxtail-shaped, white-to-gray beard.

The blocklike shape of Masaccio's Saint Andrew, and probably the figure's intense regard, owes something to a statue by Giovanni Pisano (ca. 1245– ca. 1319) and his workshop that originally crowned the Baptistery in Pisa [FIGURE 2].[1] In 1426, the year Masaccio executed the *Saint Andrew*, he was in that city and would have seen this and other sculptures by Pisano and his father, Nicola Pisano (ca. 1225–before 1284), the two most renowned sculptors of early-fourteenth-century Italy. As will be shown, this tendency to draw inspiration from sculpture, rather than from the paintings of near contemporaries, is an essential characteristic of Masaccio's revolutionary style.

As simplified as the bulky outline of Masaccio's Saint Andrew appears, it is animated by some of the most dynamic and convincing drapery design in Italian painting to date. At the right, the saint's robes cascade from the left shoulder, appearing increasingly bunched as they descend toward his left hand. In contrast to Andrew's left sleeve is the uppermost swath of drapery that arches uninterruptedly over his back down to the base of the cross, while effectively highlighting the saint's expressive head and echoing the shape of the arch

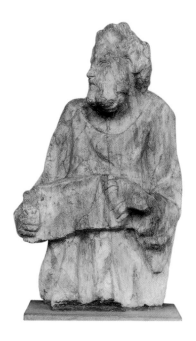

above. Here Masaccio conveys an impressive sense of forward motion by the conjunction of this same fold, the cross whose sidepiece trails off behind the figure's shoulder, and the plunging line formed by his beard and sloping chest. These three diagonal axes converge at Andrew's right hand at a point that—in contrast to usual contemporary painting practice—lies flush with the very edge of the picture plane. The motif serves to impel the saint forward, an effect reinforced by two other features of the drapery design: the parallel folds that cascade down the subject's torso and two broad loops that stand out amid the shadowed area at right.

There was only one other artist in Masaccio's Florence who modeled drapery this way—Donatello (1386[?]–1466), one of the greatest sculptors in the history of Italian art. Active since 1401, he had produced by the mid-1420s a series of heroic standing figures of unsurpassed authority for two public sites in Florence, the cathedral bell tower, or campanile, and the exterior of the guild church of Orsanmichele [FIGURE 3]. One niche at the second of these locations contained Donatello's *Saint Louis of Toulouse* [FIGURE 4] of about 1423,[2] whose generous play of drapery was a major inspiration for Masaccio's *Saint Andrew*.[3] The same statue also influenced the drapery design of an earlier Masaccio figure, that of Saint Peter in *Saint Peter Distribu-*

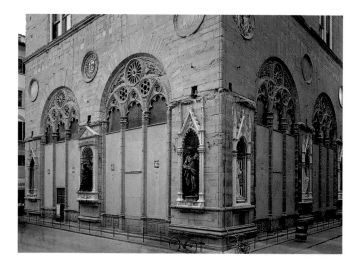

*ting Alms* [FIGURE 5], one of the frescoes in the Brancacci Chapel of Santa Maria del Carmine in Florence. It even had an impact on Masaccio's earliest surviving work, the San Giovenale Triptych [FIGURE 6], which is dated 1422. There the way Donatello's young bishop grasps his crozier was repeated by Masaccio in the figure of Saint Juvenal, who appears at the right of the altarpiece [FIGURE 6].[4] As that painting was finished one year before the completion date of *Saint Louis of Toulouse*, Masaccio must have known the statue when it was still in Donatello's studio. Such a scenario is entirely plausible. As we will see, the two artists were not only friends, but Donatello's revolutionary art was also a lasting inspiration for the young painter.

Masaccio's *Saint Andrew* can be imagined as a palpable, living being who occupies space. The drapery suggests mass and movement. The various textures, from the saint's head of hair and beard to the plain weave of his garment, are carefully yet unpedantically rendered. What most gives life to the figure, though, is Masaccio's depiction of light. It models the forms to suggest a three-dimensional reality. This achievement, revolutionary in Masaccio's day, is one of the painter's signal contributions to art history. The other is his vision of a heroic humanity, which is achieved with an intense economy of means and uncanny empathy with his subject matter. In an ultimately inexplicable manner, the lofty message of his art—its grandeur and gravitas—is perfectly conveyed by the artistic means at his disposal.

As we will see, this accomplishment is epitomized by the altarpiece of which the *Saint Andrew* panel once formed a part. The Getty Museum's picture thus introduces one of the truly great polyptychs, or multipaneled paintings, in the history of Italian Renaissance art. Between February and December 1426, the so-called Pisa Altarpiece was produced for the chapel of a notary in the church of Santa Maria del Carmine in Pisa. Despite its importance, such was the dynamic development of Italian painting in the century that followed that the style of Masaccio's polyptych soon became outdated.[5] The history of its subsequent ownership is obscure. Within 160 years

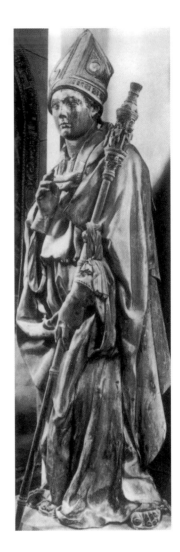

**Figure 4**
Donatello (Italian, 1386[?]–1466), *Saint Louis of Toulouse*, ca. 1423. Gilded bronze, H: 266 cm (105 in.). Florence, Museo dell'Opera di Santa Croce. (Reproduced from Paul Joannides, "Masaccio, Masolino and Minor Sculpture," *Paragone* 451 [September 1987].)

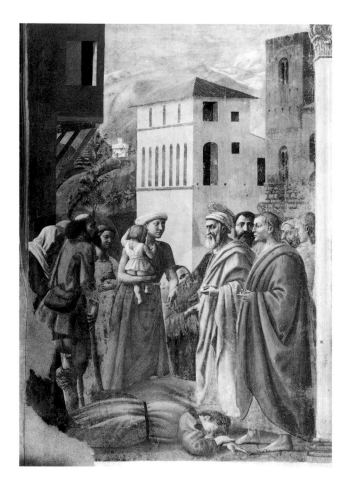

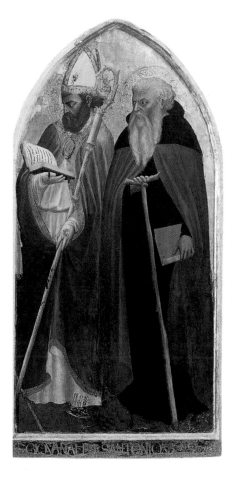

of its installation, the altarpiece had been taken down and dismantled. Its component panels were dispersed, some eventually to be identified by art historians, and others—it would seem—to be irrevocably lost.

With all of the available evidence at hand, we can reconstruct—at least partially—what Masaccio's Pisa Altarpiece would have originally looked like [see FOLDOUT], with the Getty Museum's *Saint Andrew* occupying a position on the third level at the far right. This book will examine the commission for Masaccio's altarpiece, its patron and program. It will incorporate new information about the donor, Ser Giuliano di Colino di Pietro degli Scarsi da San Giusto, a prosperous and prominent notary from Pisa. It will discuss the painting's original location in Ser Giuliano's chapel (destroyed about 1568) in Santa Maria del Carmine. It will also provide an overview of the role that the friars associated with that church would have played in the actual commis-

sion. Finally, after examining the polyptych's constituent panels, it will trace their later history in detail and recount how art historians came to identify them.

But before discussing the altarpiece itself, two other investigations must take place. First, we need to learn more about Masaccio's life and career, the subject of the following chapter. Second, it is time to describe the physical makeup and condition of the Getty's panel painting.

Masaccio's *Saint Andrew* is painted on three vertical planks of poplar wood, which was the usual support used for early Italian panel paintings. Curiously, the quality of the wood is very poor. On the back of the panel [FIGURE 7], which retains its original thickness of 1.9 centimeters, there are visible splits, and the grain in places is "very wavy and uneven."[6] At some undetermined time, the panel was cut horizontally at the top, just above the top of Andrew's halo.[7] (The present replacement in this area was added as of January 1987, as was the modern frame.) When the picture was acquired by the Museum in 1979, the missing upper corners had been filled in with pine pieces so that, presumably, the panel would fit an earlier, rectangular-shaped frame.

The bottom of the panel has also been cropped. This is evident when another extant panel from the same register of Masaccio's altarpiece, the *Saint Paul* in the museum at Pisa [FIGURE 8], is compared with the unframed *Saint Andrew* [FIGURE 9]. There the original extent of the paint surface, which measures 50 by 29.2 centimeters, remains intact.[8] The comparable dimensions of the *Saint Andrew* (including the height of the addition) are, on the other hand, 46.1 by 30.2 centimeters, implying that some four centimeters of the painted surface have been deleted from its base. The original width of the painted surface of the *Saint Andrew* has not been diminished, since its present width corresponds generally with that of the *Saint Paul*.[9]

Within a year of the Museum's acquisition of the painting in 1979, Masaccio's *Saint Andrew* underwent conservation treatment at the hands of David Bull. Removal of the heavy brown overpaint and yellowed varnish

**Figure 7**
Masaccio, *Saint Andrew*
[reverse of panel].

5

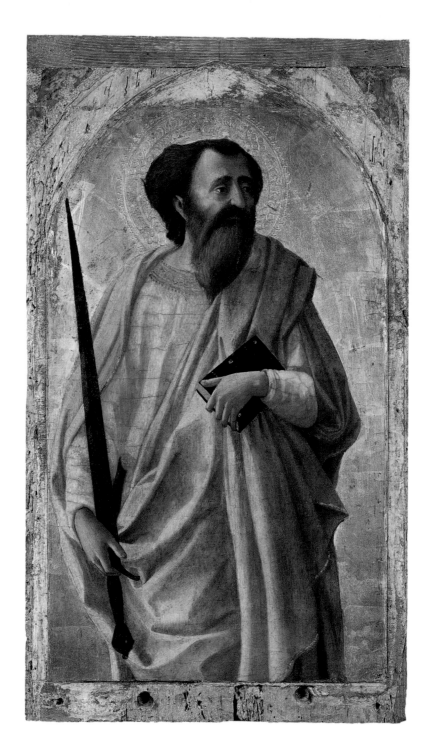

**Figure 8**
Masaccio, *Saint Paul*,
1426. Tempera and gold
leaf on panel, 50 × 29.2
cm (19 11/16 × 11½ in.).
Pisa, Museo Nazionale
e Civico di San Matteo
(110). Photo: © Scala/
Art Resource, NY.

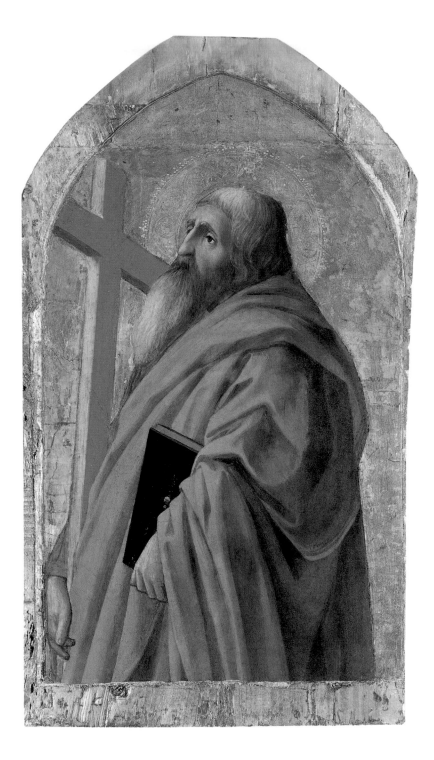

**Figure 9**
Masaccio, *Saint Andrew*
[without modern frame].

that had obscured Saint Andrew's robes revealed the present green (the saint's traditional color). There are partial remains of a dark green glaze layer in the shadowed area at the right. The green pigment was found to be composed of lead white tinted with lead tin yellow and malachite, which, unlike the alternative green pigment of copper resonate, resists discoloration.[10] Very minor paint losses were found in the figure's head, hair, and hands. Otherwise the paint surface had remained in good condition, save for some sinking and abrasion in the area of Andrew's hair. Minor inpainting was undertaken, including some reglazing in the green robes at the right. The paint surface was then covered with a synthetic resin varnish.

# MASACCIO'S LIFE AND WORK

Masaccio [see FIGURE 10] came from San Giovanni Valdarno, a thriving town on the Arno River about halfway between Arezzo and Florence. Founded in 1296 as a bulwark against the Ubaldini clan of Arezzo—hence its original name of Castel San Giovanni—the town was a dependency of the burgeoning Florentine Republic. This relationship was confirmed in 1408, when the place became the episcopal seat, or *vicariato*, of the upper Arno valley;[11] from then on it formed part of the bishopric of Fiesole, just to the north of Florence. Masaccio's home still stands in San Giovanni Valdarno on a street named in his honor.

The painter was born in 1401 on December 21, the feast day of Saint Thomas. He consequently was named Tommaso. No contemporary documents use the nickname by which he is known to history, Masaccio,[12] which translates literally as "dreadful Tom." In the context of fifteenth-century Florence, however, its more likely meaning would have been "sloppy Tom," an allusion to the bohemian ways Giorgio Vasari ascribes to him in his life of the painter.[13] Masaccio's full name was Tommaso di Ser Giovanni di Mone Cassai, or, translated, Thomas the son of Master John the son of Simone Cassai. His father, Ser Giovanni Cassai, was a notary, and thus a member of the professional classes. On the other hand, Masaccio's paternal grandfather and great-uncle, Mone di Andreuccio Cassai and Lorenzo Cassai, were both woodworkers. In fact, the two probably owed their surname, a rare distinction in Tuscany until about the late fifteenth century, to a professional subspecialty, that of *cassai*, or maker of wooden boxes and notions.

In 1406 Masaccio's father died, at about age twenty-six. Soon afterward his widow, Monna Jacopa di Martinozzo di Dino, the daughter of an innkeeper from the Mugello region north of Florence, gave birth to a second son. Baptized Vittorio, he later took his father's name, Giovanni, though he more commonly went by the nickname Lo Scheggia (which translates as "chip" or "splinter"), a reference either to his grandfather Cassai's profession or, perhaps, to some

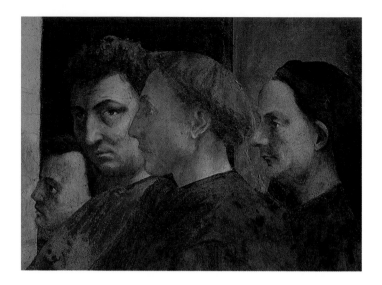

personal characteristic, such as skinniness. Scheggia (1406–1486) likewise grew up to be a painter, sometimes acting as his brother's assistant. The contrast between his career and that of Masaccio could hardly be more extreme: over a long and productive lifetime, Scheggia's style barely changed and had almost no impact on later art. Masaccio, on the other hand, lived slightly longer than his father, dying (historians have deduced) in about June 1428. In contrast to Scheggia, he was a genius who decisively altered the course of art history.

Scheggia left a brief account of Masaccio's life, dated September 15, 1472, in which he provided the painter's birth date and age—"circa twenty-seven"—when he died. Some twenty years later, this text was incorporated into a manuscript, "XIV Uomini singhulari in Firenze," by Antonio Manetti, a pupil of the architect Filippo Brunelleschi (1377–1446), who was a friend and mentor of Masaccio's.[14] Manetti also enumerated all of Masaccio's works in Santa Maria del Carmine in Florence, adding "he also made [paintings] in other locations in Florence, in churches and for private individuals, as well as in Pisa and Rome and elsewhere."

There are no documents indicating any aspect of Masaccio's artistic training. Were his grandfather or great-uncle still alive during his youth (their dates are unknown), one or both may have taught Masaccio the craft of woodworking, including perhaps intarsia design. Two indications suggest such a training. First of all, Masaccio's brother is known to have designed and executed wooden intarsia work. Second, in the earliest Florentine document to mention Masaccio, one dating from after October 14, 1418, the young artist acted as a guarantor for a woodworker from San Giovanni Valdarno who had recently

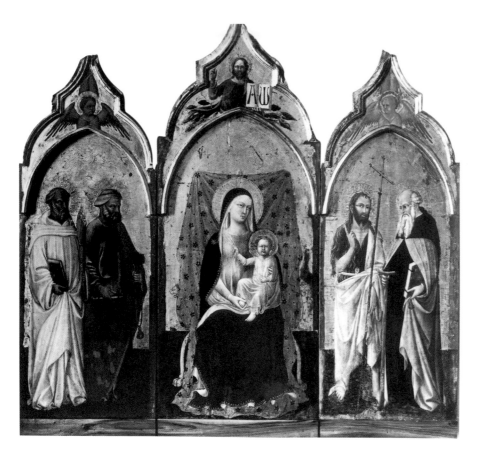

**Figure 11**
Mariotto di Cristofano
(Italian, ca. 1395–
ca. 1458), *Madonna and
Child between Saints
Benedict and Peter; John
the Baptist and Anthony
Abbot,* ca. 1435.
Tempera and gold leaf
on panel, 168 × 182 cm
(66⅛ × 71⅝ in.).
Whereabouts unknown,
formerly Preci (near
Norcia), Umbria, parish
church of Santa Maria.
Photo: Fiorucci.

matriculated in the woodworkers' guild.¹⁵ This last reference confirms that Masaccio, here described as "painter," had some contact with the woodworking profession. It also implies that he already enjoyed some repute, even though he had yet to attain the rank of master artist.

Masaccio's mother continued to live in San Giovanni Valdarno, where she remarried, sometime after 1412, a substantially older, well-to-do apothecary named Tedesco di Maestro Feo. This information has some bearing on Masaccio's professional milieu, since one of Tedesco's daughters from a previous marriage would marry, probably in 1422, a local painter called Mariotto di Cristofano (ca. 1395–ca. 1458). By that time, Mariotto had settled in Florence, having enrolled in the woodworkers' guild in January 1419. He may have had an impact on Masaccio's choice of career, although his known paintings have little in common with those of the younger painter. Still, in Mariotto's Preci altarpiece [FIGURE 11], the motif of the Virgin's right hand firmly clasping her son's right foot resembles the arrangement in Masaccio's San Giovenale Triptych of 1422

[FIGURE 12]. Although Mariotto's altarpiece is dated about 1420, it may in fact have been created some fifteen years later, in which case the influence from one painter to another would have worked in reverse.[16]

Masaccio's stepfather made his will in June 1417 and died within a year.[17] Nowhere in the extensive documentation pertaining to his estate are his stepsons, Masaccio and Scheggia, mentioned, leading one to suspect that they had already moved to Florence, the natural destination at that time for any aspiring painter. Presumably it was for their account that rent was paid, from their mother's inheritance, to one Piera de' Bardi for lodging in the Florentine parish of San Niccolò Oltrarno sometime before 1420.[18] This part of Florence was the preferred locale for settlers from San Giovanni Valdarno, being just within the city's southeastern walls and thus en route to Masaccio's native town. San Niccolò is again listed as Masaccio's home parish on January 7, 1422, at which time he matriculated in the doctors and apothecaries' guild (the Arte dei Medici e Speziali) to which the Florentine painters belonged.[19]

For Masaccio to have joined the painters' guild in Florence indicates that several years of apprenticeship (at least three, according to Florentine law)[20] must have taken place. Yet again there are no records of whom Masaccio trained with. Scheggia, on the other hand, is documented twice in the workshop of Bicci di Lorenzo (1373–1452), on February 13 and October 30, 1421.[21] Because of this connection, it is sometimes said that Masaccio might have studied with Bicci, one of the most dependable and prolific painters in early quattrocento Florence. Yet, as we will see, the stylistic evidence does not support this deduction. In fact, Bicci did not train Scheggia as a painter either, at least not at this early stage, for the latter, by his own account, had another profession in 1421, that of soldier. Thus, in his two appearances in Bicci di Lorenzo's workshop, Scheggia most likely functioned as a messenger.[22]

Bicci, however, may well have been a friend or perhaps even a mentor of Masaccio's in the parish of San Niccolò. From 1421 to 1422 he was active in the same quarter of the city, executing frescoes (since destroyed) in the church of Santa Lucia dei Magnoli for Ilarione de' Bardi, no doubt a relation of Masaccio's landlady, Piera de' Bardi. It was also through Bicci, presumably, that Masaccio first met Andrea di Giusto Manzini (ca. 1400–1455), who was recorded in Bicci's shop on December 23, 1421, and who would later assist Masaccio on the Pisa Altarpiece. Finally, in about 1430, Bicci followed suit with a panel painting for another chapel also in Santa Maria del Carmine in Pisa. Given these multiple connections, one can at least conclude that Masaccio and Bicci were acquainted.

On January 7, 1422 (as we have seen), Masaccio enrolled in the painters' guild and so functioned as an independent master. His first surviving work bears the date of April 23, 1422 [FIGURE 12].[23] Found in the church for which it

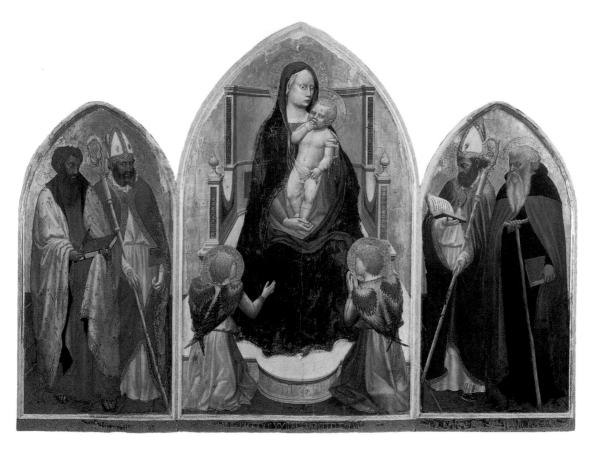

was undoubtedly made, San Giovenale nei pressi di Cascia in the village of Regello (near San Giovanni Valdarno), it depicts in the center the Virgin and Child adored by two kneeling angels, with Saints Bartholomew and Blaise in the lefthand panel and Saints Juvenal and Anthony Abbot in that at the right.

   As is often the case with Italian Renaissance art, the choice of saints helps identify the painting's patron. Three of the standing figures, Bartholomew, Juvenal, and Anthony Abbot, were patron saints of the most powerful family in the upper Arno Valley, the Castellani. Moreover, the two innermost saints display croziers in an almost heraldic way that probably refers to the personal device of Vanni Castellani. Vanni, whose father had been an important patron of the painter Agnolo Gaddi (act. 1369–96) in Florence, died in March 1422. It was presumably his estate that funded Masaccio's altarpiece, completed one month later.[24]

   The San Giovenale Triptych is not signed, nor do any documents associate it with Masaccio. Yet ample visual evidence confirms an attribution to that

**Figure 12**

Masaccio, *The San Giovenale Triptych*, 1422. Tempera and gold leaf on panel, side panels: 88 × 44 cm (34⅝ × 17¼ in.); central panel: 108 × 65 cm (42½ × 25⅝ in.). Cascia di Regello, parish church of Santi Pietro e Paolo. Photo: © Scala/Art Resource, NY.

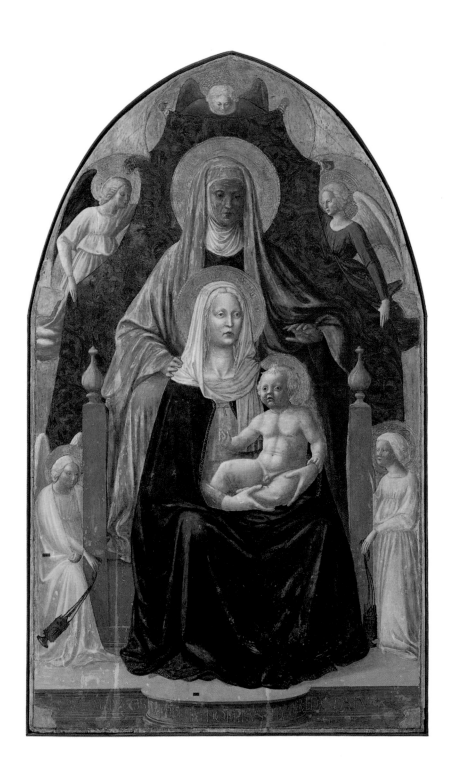

painter. The austere Madonna anticipates the same figure in *The Madonna and Child with Saint Anne* [FIGURE 13], which was executed by Masaccio and Masolino, a far more conservative artist, some two years later. The sculptural Christ child resembles that in the later painting, while the motif of his licking his fingers reappears in the central section of Masaccio's Pisa Altarpiece of 1426 [see FOLD-OUT]. As in the latter panel, here an architectonic throne almost totally obscures the gold-leaf background, while its spatial thrusts enhance the sculptural volume of the Virgin and Child. Finally, the shaggy figures at the right correspond with some of the fierce, older men seen in the Brancacci Chapel frescoes, which Masaccio was to begin painting some two to three years later.

Compared to these later pictures, the San Giovenale Triptych hardly signals the work of a prodigy. There is a stylistic discrepancy, for instance, between the more traditionally painted side panels and the hard-edge forms of the Virgin and Child. Nor are the styles of the two panels of saints identical. The figures in the left-hand panel are more repetitive and stereotypical than the expressive ones of Saints Juvenal and Anthony Abbot. These and other aspects have even led some writers to dismiss the attribution to Masaccio. However, the painting's uneven quality may be due instead to the extended amount of time the painter devoted to this work, in which, beginning with the panel of Saints Bartholomew and Blaise, his style progressed dramatically.

There is reason to believe that in these same, more conservative parts of the San Giovenale Triptych the identity of Masaccio's master may yet be found. The figures of Saints Bartholomew and Blaise have suggested to art historians the influence of Bicci di Lorenzo, Giovanni dal Ponte (1385–1447), and the Master of 1419, so named for this anonymous Florentine painter's dated altarpiece originally in the Mugello region north of Florence [FIGURE 14].[25] The latter painting may have been known to Masaccio, given that his mother hailed from the Mugello. Perhaps he even got the idea of the tiles set in proper perspective from that painting as well. Yet despite this progressive feature, the Master of 1419's style, with its artificial, elongated figures, bespeaks another trend, that of such Gothic masters as Lorenzo Monaco (ca. 1375–ca. 1423), the most prominent Florentine painter of his day. But with that stylistic trend Masaccio's 1422 altarpiece shows nothing in common.

As for the comparison of Masaccio's Saints Bartholomew and Blaise with the art of Bicci di Lorenzo—compare, for instance, the latter's altarpiece of 1430, formerly at Vertine [FIGURE 15]—there is little similarity of forms. Closer, perhaps, are the paintings of Giovanni dal Ponte, a relatively sophisticated painter whose earliest work dates from 1410.[26] The comparison, which is of a general sort, extends to a similar "broad execution with strong contrasts of light and shade," two features found in Masaccio's San Giovenale Triptych.[27] Yet

**Figure 13**
Masaccio and Masolino (Italian, 1383/84–1435), *The Madonna and Child with Saint Anne*, ca. 1424–25. Tempera and gold leaf on panel, 175 × 103 cm (68⅞ × 40½ in.). Florence, Galleria degli Uffizi (8386). Photo: © Scala/Art Resource, NY.

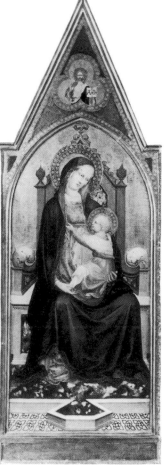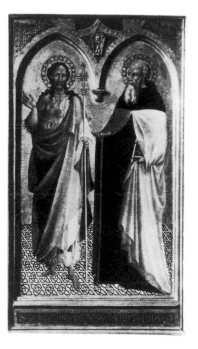

there is no particular reason—either in any discernible pattern of shared patronage or other related experiences—to suggest that Masaccio actually studied with that painter.

An ultimately more revealing task than ascertaining Masaccio's master is that of identifying some of the wellsprings of his style. Let us turn to the central panel of Masaccio's triptych. As several authors have demonstrated, the commanding figure of the Virgin Mary pays homage to Giotto's *Madonna* [FIGURE 16], then in the church of Ognissanti, a work whose prestige in the past one hundred years had never waned. Giotto's fame was legendary, and it seems typical of the ambitious young painter from the provinces that he had already set his sights so high.

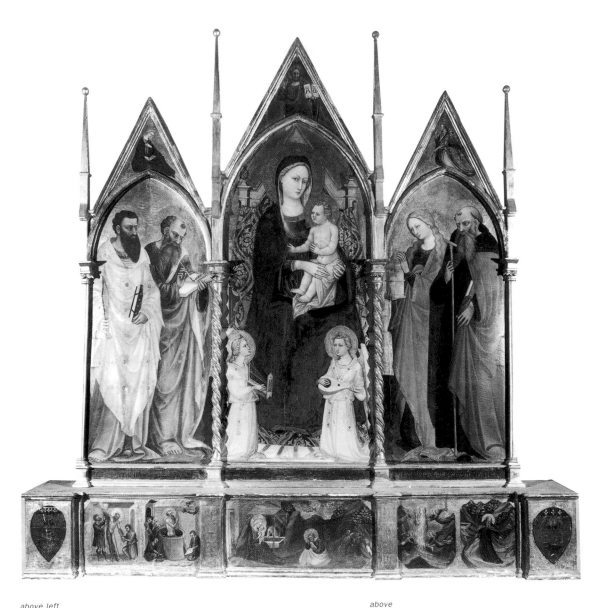

*above left*

**Figure 14**

Master of 1419 (Italian), *Madonna and Child between Saints Julian and James; John the Baptist and Anthony Abbot*, 1419. Tempera and gold leaf on panel, 195.6 × 68.1 cm (77 × 26 13/16 in.), left panel;

196.2 3 54.8 cm (77¼ × 21½ in.), central panel; and 61 × 21.9 cm (48 × 26 in.), right panel. Great Britain, private collection (left panel); Cleveland Museum of Art (54.834) (central panel); and Zurich, heirs of Dr. Gustav Rau (right panel).

(Reconstruction reproduced from B. Berenson, *Italian Pictures of the Renaissance: Florentine School* [London, 1963], I, pl. 550).

*above*

**Figure 15**

Bicci di Lorenzo (Italian, 1373–1452), *Madonna and Child between Saints Bartholomew and John the Evangelist; Mary Magdalen and Anthony Abbot*, 1430. Tempera and gold leaf on panel, 186 × 190 cm (73¼ ×

73¾ in.). Siena, Pinacoteca Nazionale (on deposit from the church of San Bartolommeo, Vertine in Chianti). Photo: Courtesy Ministero per i Beni e le Attività Culturali, le province di Siena e Grosseto.

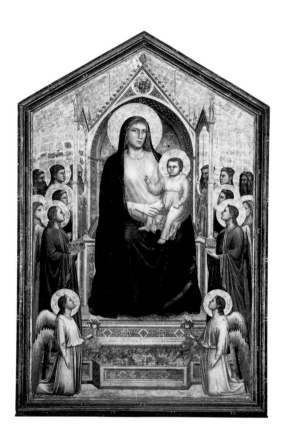

**Figure 16**
Giotto (Italian, 1266/
67–1337), *The
Ognissanti Madonna*,
ca. 1310. Tempera and
gold leaf on panel,
325 × 204 cm (128 ×
80¼ in.). Florence,
Galleria degli Uffizi
(8344). Photo: ©
Alinari/Art Resource, NY.

The San Giovenale Triptych also makes reference to the new visual world then being articulated in Florence by arguably its most pioneering talent, Donatello. We have already seen how that sculptor's *Saint Louis of Toulouse* of about 1423 was a source for the motif of Saint Juvenal's left hand and crozier as well as for the drapery style of the Getty Museum's *Saint Andrew*. The head of that gilded statue [FIGURE 17], moreover, seems to have been the inspiration for that of Masaccio's Virgin [FIGURE 18].[28] The firm contours of the Christ child likewise invite comparisons with contemporary sculpture. His head and right forearm are almost a quotation from Donatello's *Orlandini Madonna*, a lost relief dating from the early 1420s, which is known from a studio version in marble in Berlin. Finally, the intense way in which the Virgin wraps her spindly fingers around her son's left shoulder is a motif very likely drawn from a terra-cotta statue attributed to Nanni di Bartolo (documented 1419–51), now in the National Gallery of Art, Washington, D.C.[29]

The San Giovenale Triptych is, in sum, an ambitious work. The spirit of its central panel is that of "Giotto born again"—Bernard Berenson's characteri-

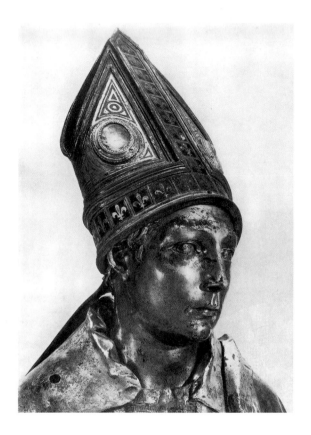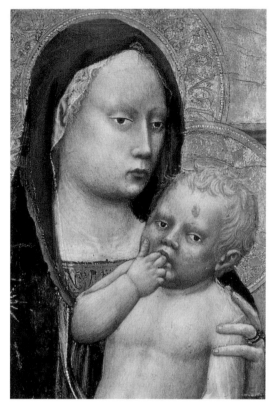

zation of the painter.[30] Other, more expressive details draw inspiration from sculpture, especially that of Donatello, whose art was to serve as a catalyst for the young painter for the rest of his short career. And in the dynamic artistic center of Florence of 1422—where statues by Donatello, Lorenzo Ghiberti (1378–1455), and Nanni di Banco (ca. 1384–1421), among others, had transformed the public arenas of daily life—it was sculpture above all that heralded the confident, new, monumental style that would eventually earn the epithet Renaissance.[31]

Familiar as he was with such pioneering artists, Masaccio still had an ever-present practical need: to support himself in this highly competitive new setting. The painter's debts, as we learn from his tax declarations of 1427, were considerable, while other documents suggest that both his working and living quarters were modest.[32] Probably for these reasons, Masaccio teamed up with another painter from the upper Valdarno region, Tommaso di Cristofano, better known as Masolino.

Masolino was Masaccio's elder by some seventeen years.[33] According to early-sixteenth-century sources, he had been apprenticed to Agnolo Gaddi.

**Figure 17**
Donatello, *Saint Louis of Toulouse* [detail of Figure 4]. [Reproduced from John Pope-Hennessey, *Italian Renaissance Sculpture: An Introduction to Italian Sculpture* [Oxford, 1986].

**Figure 18**
Masaccio, *The San Giovenale Triptych* [detail of Figure 12].

Vasari states that in his nineteenth year Masolino entered the studio of Starnina (d. ca. 1413),[34] whose oeuvre has now been equated with that of the anonymous Master of the Bambino Vispo. Starnina's sophisticated, linear style is in fact reflected in the early paintings of Masolino, confirming Vasari's supposition about the latter's training. Moreover, the two worked at different times at the same locations, as in the church of Santo Stefano in Empoli (west of Florence) and in Santa Maria del Carmine in Florence, where Masolino is first documented in 1425. Masolino then (again according to Vasari) became an assistant of the sculptor and architect Lorenzo Ghiberti, in whose workshop he is documented between 1407 and 1415.

By 1415 Masolino had worked for some of the leading practitioners in Florence of the International Gothic style. His first dated painting, *The Madonna and Child* [FIGURE 19] of 1423, now in Bremen, reflects such training. Soon afterward, though, Masolino's style took on a pronounced Masacciesque cast, the result of his roughly four-year association with the younger painter. There are even historical parallels between the Bremen *Madonna and Child* and Masaccio's San Giovenale Triptych of 1422: each artist produced his work in the same year that he joined the Florentine painters' guild (in Masolino's case, on January 18, 1423), and both works were commissioned by members of powerful families from the upper Valdarno region from whence both artists sprang. Thus one of the two coats of arms on the base of Masolino's painting belongs to the Carnesecchi, who, like the Castellani clan, had large holdings in the upper Arno valley.

A member of this same family, Paolo di Berto Carnesecchi, then engaged Masolino to execute an altarpiece for his chapel in Santa Maria Maggiore, Florence. According to early sources, this included a predella by Masaccio and a frescoed ceiling and arch by Paolo Uccello (1397–1475), a fellow pupil of Masolino in Lorenzo Ghiberti's workshop. The church and its frescoes are long gone, and all that remains of the altarpiece is its central panel (a stolen *Madonna and Child*, formerly in the church of Santa Maria, Novoli), the right-hand panel of *Saint Julian* (Museo

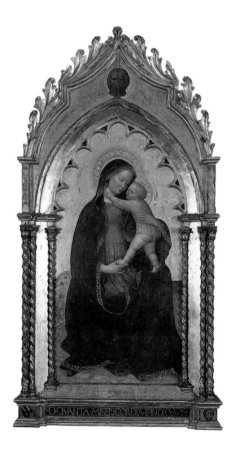

**Figure 19**
Masolino, *The Madonna and Child*, 1423. Tempera and gold leaf on panel, 96 × 40 cm (37¾ × 15¾ in.). Bremen, Kunsthalle (164).

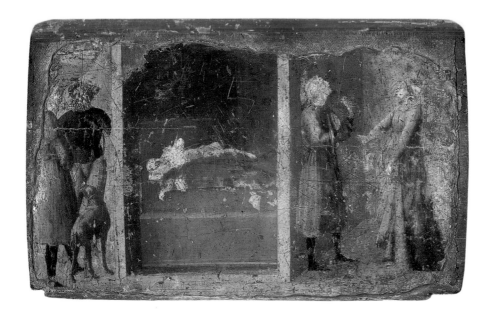

**Figure 20**
Masaccio, *Scene from the Legend of Saint Julian*, ca. 1424. Tempera and gold leaf on panel, 24 × 43 cm (9 7/16 × 16 7/8 in.). Florence, Museo Horne (60). Photo: © Scala/ Art Resource, NY.

d'Arte Sacra, Florence), and the right section of Masaccio's predella, which depicts the principal scene from the legend of that saint [FIGURE 20].[35] Although much damaged, this panel shows Masaccio's early and revolutionary use of light to model the forms. It provides a window into another, visually convincing world, which Leon Battista Alberti (1404–1472) later described as painting's essential function.[36] As Masaccio's first surviving narrative scene, it also evidences the dramatic force and economy of means that were to be the hallmarks of his style.

Masaccio and Masolino's next collaborative project was *The Madonna and Child with Saint Anne* [FIGURE 13], which has been dated between late 1424 and early 1425.[37] The panel's original destination is not recorded, although it may have been the Florentine church of Sant'Ambrogio, where Vasari described it. The facts of its commission are also unknown. However, as was undoubtedly the case with the Carnesecchi Triptych, the order for this painting probably went to the far more experienced Masolino. Unlike in their earlier collaboration, Masaccio played a central role. He executed the figures of the Virgin and Child, the angel at the upper right, and the foreshortened angel at the top, which is seriously damaged and abraded. The rest was done by Masolino, who also was responsible for the painting's overall design.

Masaccio's imposing Virgin Mary is strongly reminiscent of the Virgin in his San Giovenale Triptych of 1422. Here too the spirit of Giotto's *Ognissanti Madonna* recurs, especially in the Virgin's simple silhouette and the bold massing

of her draperies.[38] The blue mantle from which her head appears to subtly emerge in the two earlier images has been exchanged for a white one. This beautiful feature—a considerable advance in Masaccio's mimetic powers as a painter—provides a frame for the austere, yet convincingly modeled face.[39] The latter, emphasized by the direct play of light, is in fact the highlight of the composition. The Herculean Christ child, which may have been based on a Roman marble,[40] evidences a more sharply contrasted chiaroscuro.

In the Uffizi painting [FIGURE 13], Masaccio's impassive Virgin Mary holds her son in a rigid gesture seemingly devoid of emotional contact. In contrast is Masolino's solicitous Saint Anne. Set partially in shadow, she places one hand on her daughter's right shoulder and, in a marvel of foreshortening, extends her left hand protectively over Christ. A similar tenderness is evident in the way he, in turn, folds his foreshortened fingers over his mother's left wrist. His whole body indicates movement. These features contrast with the stillness of the Virgin, which further contributes to her mystic, God-like air.

Just about the time that Masaccio executed his share of *The Madonna and Child with Saint Anne*, he painted a *Madonna of Humility* [FIGURE 21], now in the National Gallery of Art, Washington, D.C.[41] Here the painting's poor condition was compounded by two radical reworkings of the paint surface and gold ground: once before 1929, when it was acquired by the firm of Duveen Brothers, and sometime before 1937, when it was purchased by Andrew W. Mellon. Still, photographs from the Duveen archives of the painting in its stripped state, first published in 1980,[42] confirm the attribution to Masaccio, which until then had been increasingly called into question. The picture's real and potential beauties became even more evident as later inpainting was removed during a recent conservation.[43]

Although much of the original paint surface of the two angels' heads is lost, the lighting on these figures and the impressive modeling of their draperies recall the two angels executed by Masaccio as part of *The Madonna and Child with Saint Anne* [FIGURE 13]. Also comparable in both compositions is the modeling of the Virgin's head [FIGURES 22, 23]. Cleaning has revealed a more plastic and convincing rendering of the Virgin's dress. In addition, Masaccio's skills as a draftsman are now more apparent, thanks to infrared reflectography, which has uncovered part of the picture's underdrawing, as in the delicate rhythm of the Christ child's left hand and in the outlines of the Virgin's face. All of these newfound features suggest an advance over the Uffizi *Madonna and Child with Saint Anne*, implying that *The Madonna of Humility* was executed slightly later.[44] The awkward positioning of the Virgin's legs has sometimes been said to argue against the attribution to Masaccio, yet a similar deficiency is apparent in the crouching figure of Saint Peter at the left in *The Tribute Money* [FIGURE 26], which postdates *The Madonna of Humility* by about one year.

**Figure 21**
Masaccio, *The Madonna of Humility*, ca. 1424 [photograph of painting in stripped state]. Tempera and gold leaf on panel, 105 × 54 cm (41 5/16 × 21 1/4 in.). Washington, D.C., National Gallery of Art, Andrew W. Mellon Collection (7).

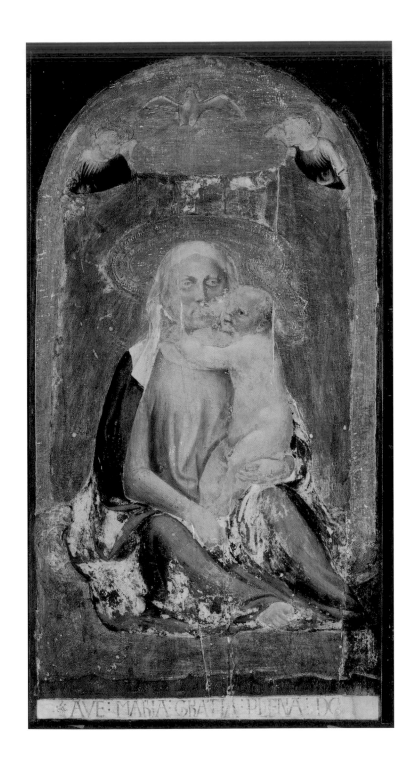

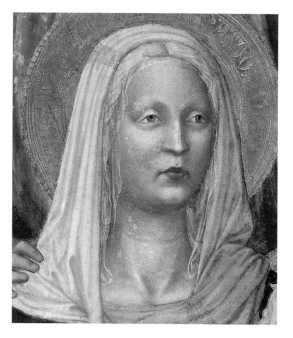

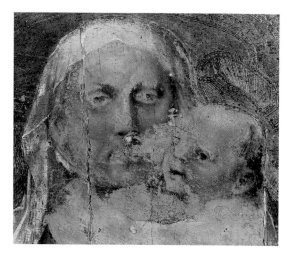

The Washington painting may be identical with an otherwise untraced picture of "Our Lady in a tabernacle" mentioned in a document of August 23, 1426.[45] On that occasion, a certain furrier sued the painter for "a section of wolf's paws" for which Masaccio's painting had served as partial payment. Even if not identifiable with the Washington panel, the furrier's painting does disclose something about Masaccio's state of affairs by 1426. With important commissions directed his way (the Pisa Altarpiece, which engrossed him for much of that year, as well as his finished sections of the Brancacci Chapel frescoes), Masaccio still had unsold pictures in his studio, presumably made "on spec." Nor was he above doing the usual, comparatively routine tasks of a painter in fifteenth-century Italy. Thus on June 5, 1425, Masaccio and another artist were paid for gilding processional candlesticks for the cathedral of Fiesole,[46] in the same ecclesiastical district as that of San Giovanni Valdarno.

There are no contemporary documents that mention Masaccio's greatest claim to fame, the Brancacci Chapel frescoes in Santa Maria del Carmine, the Carmelite church in Florence.[47] Like *The Madonna and Child with Saint Anne*, this too involved a joint venture with Masolino. Here both painters were in good company, for in the church were important fresco cycles by earlier artists, such as Agnolo Gaddi, Spinello Aretino (act. 1373–d. 1410), and Starnina, and altarpieces by Lorenzo Monaco and Bicci di Lorenzo.

The basic source for the Brancacci Chapel's original scheme is Vasari, who, though wrong on certain facts (according to him, Masaccio outlived Masolino), does provide a starting point for determining the individual contribution of each artist, as well as a rough chronology. Masolino, he wrote, began the project, which, according to the usual sequence of fresco painting, started from the top sections and worked down.[48] The uppermost level, all of which was effaced over two centuries ago, consisted of depictions of the Four Evangelists on the groin vault ceiling and four scenes of Christ, Saint Peter, and other apostles on the lunette walls just below: *The Calling of Saints Peter and Andrew* (whose composition is recorded in two copies), *Christ Rescuing Saint Peter*, and two other scenes—*The Penitence of Saint Peter* and *Christ's Injunction: "Feed My Sheep"*—whose compositions are partially known thanks to surviving *sinopie* (preparatory line drawings on the fresco underlayer). These were recovered in the course of the chapel's momentous restoration of 1984–90.

Masolino began the cycle either in the fall of 1424, after he had completed similar work in Empoli, or, at the latest, early in the following spring, since the technique of fresco painting is harder and far slower during the damp winter months. After this juncture there were two more levels to fresco: the two long walls, the altar wall at either side of the window—the chapel's only light source—and the narrow piers that flank the chapel entrance [FIGURES 24–25]. It was at this moment, probably early 1425, that Masolino called in Masaccio, with whom he had already successfully collaborated. Their work was interrupted on September 1, 1425, when Masolino left Florence for an almost-two-year stay in Hungary. Their partnership appears to have resumed only in late 1427 or 1428.

The chapel belonged to Felice Brancacci (1382–1447), a prosperous silk merchant with strong ties to Florence's social and political elite, as well as to the ecclesiastical hierarchy. It had been founded by his great-uncle Pietro Brancacci (died 1367), who had bequeathed money for its decoration. According to the testament of Pietro's son Antonio, this sum was to be supplemented by funds from his own estate and from other family members, as indeed it was. By contrast there are no payments for the Brancacci Chapel frescoes from Felice Brancacci himself. Had there been, Felice would have been entitled to include them as a deduction in his tax declaration of 1427, when (as we will see) work in the chapel was still in progress. Presumably, funding for Masaccio and Masolino's frescoes had already been made over to the church; as a result, key decisions involving their implementation devolved not so much on Brancacci but on the Carmelite authorities.[49]

Just possibly, it was the Carmelites who also selected the painters. In fifteenth-century Tuscany, they showed a preference for the work of more pro-

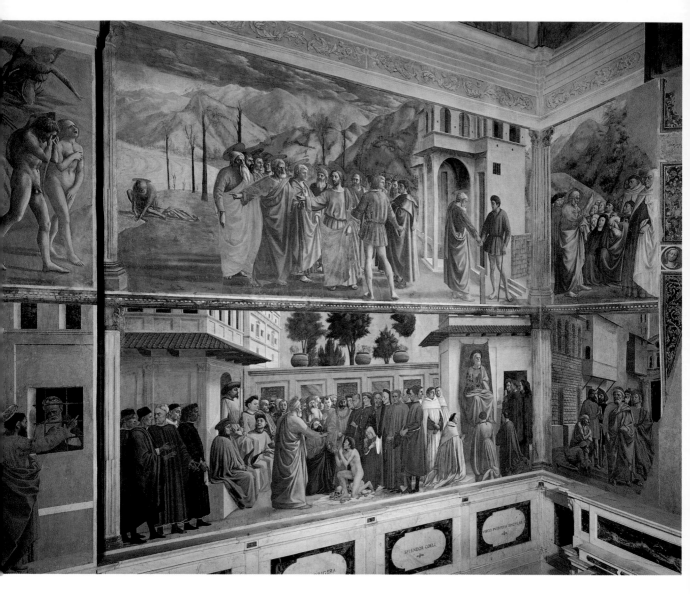

gressive artists, such as Masaccio. By 1426, he had been chosen to execute an important altarpiece for another Carmelite foundation, Santa Maria del Carmine in Pisa, of which the Getty Museum's *Saint Andrew* was once a component. It was undoubtedly the Carmelites, too, who devised the Brancacci Chapel's theological program. They would have selected the individual scenes to be painted, and it was presumably at their command that Masolino and Masaccio included portraits of various friars (none of them identifiable today) in several of the frescoes.

26

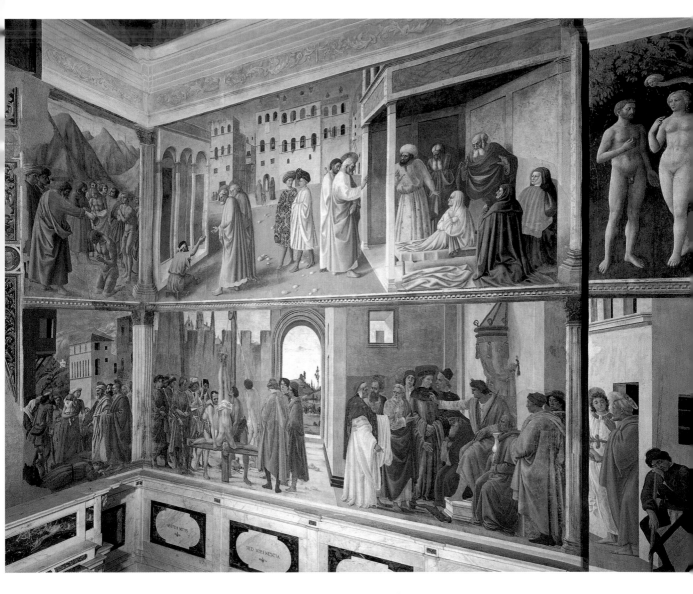

Since the Brancacci Chapel was the private property of an individual, its decoration understandably celebrated the legends and virtues of the founder's patron saint. In the case of Pietro Brancacci, therefore, the chosen subject was Peter, a saint also emblematic of the Church itself. Clearly central to the message of the Church and, by extension, to the role of the papacy, the subject was momentous. During these very years, the papacy was under attack. The Carmelites, who were fiercely supportive of the office of pope, took an active role in combating the

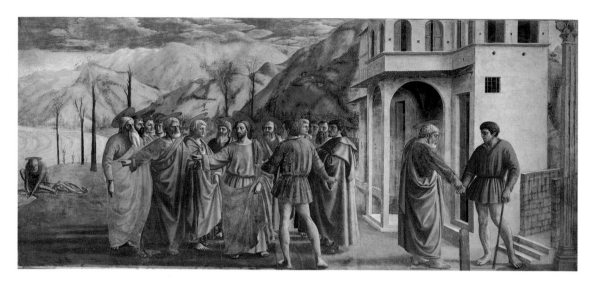

Hussite heresy, which denied Peter's position, and by extension the papacy's position, as the divinely appointed head of the Church. Given these circumstances, the Florentine branch of the Carmelite order would have looked to a mural scheme illustrating scenes of Saint Peter's life as a fitting opportunity to further their own propagandistic purposes. After all, Christ's charge to Peter in Matthew 16:18 ("thou art Peter; and upon this rock I will build my church") was enacted annually in front of the Brancacci Chapel as part of the famous Ascension play.[50]

To enhance the didactic potential of the Brancacci Chapel frescoes, Masaccio and Masolino's scenes were not laid out in sequential order. Indeed, introducing the Saint Peter frescoes on the chapel's second level are depictions of fallen Man, *The Expulsion from Paradise* of Masaccio and *The Temptation of Adam and Eve* of Masolino, both of which frame the entrance and introduce the main theme: humanity's need for salvation.[51] What follows is the famous *Tribute Money* [FIGURE 26], in which Christ, having been accosted by a tax collector (the young man in a scarlet doublet), directs Peter to go to the Sea of Galilee and extract the required tax payment, which he then delivers to the collector at far right. Masaccio depicts all four episodes in the same setting, in the traditional mode of a multiple narrative.

*The Tribute Money* bespeaks the new powers of scientific observation that typify and indeed herald the revolutionary Renaissance style. The masterful play of light, directed from the altar wall window, unifies figures and setting. As it strikes the monumental gathering of apostles at the center, the resulting shadows enable one to plot the figures' exact placement in space. Such deliberation suggests the practice of painting from sculpted models in an enclosed

boxlike space illuminated by a single light source, a practice that Masaccio most likely learned from Donatello.[52] That Masaccio was well informed of sculptural practice is also attested by the partial presence of vertical chalk plumb lines that run from below the head of certain figures down to the base of the weight-bearing leg.[53] Clearly Masaccio's intent was to replicate the volume and tactile quality of living beings, the essence of his style.

As was the case earlier in Masaccio's career, *The Tribute Money* drew inspiration from the sculpture of Donatello. Thus, the circular ground plan laid out by the standing figures shows a great debt to a silver plaque now in the Louvre that has been attributed to the sculptor. The way the architecture on the right harbors the figure of Saint Peter while conforming to the rules of one-point perspective also suggests the influence of another Donatello composition, the marble relief of *Saint George and the Dragon* of 1417 [FIGURE 27], which is the earliest surviving example of perspectival construction as established at about this time by the architect and sculptor Brunelleschi.

In the Brancacci Chapel, the Corinthian pilasters framing the lower-level scenes are also Brunelleschian; they in fact signal the first example of classical architectural vocabulary to appear in a frescoed scene since antiquity. They also suggest that at this point in the chapel's decoration, Masaccio assumed primary responsibility for its design.[54] On the upper level of the surviving fresco scenes the division of labor was evenly shared. Indeed, technical examination resulting from the frescoes' recent conservation campaign indicates that, at this level, Masaccio used precisely the same number of *giornate* in his scenes as Masolino, that is, forty-six. This was so even when, as has been recently proposed, the artists took turns executing the landscape section of the other's scenes along the altar wall.[55] Thus in Masolino's *Saint Peter Preaching* it was Masaccio who painted the mountains that merge with the background of his own *Tribute Money* to the left, whereas the comparable part of Masaccio's *Saint Peter Baptizing the Neophytes* was done by Masolino. The latter also came to Masaccio's aid in *The Tribute Money*, executing the head of Christ.[56] Clearly, the collaboration of the two painters "was simultaneous, not sequential."[57]

**Figure 27**
Donatello, *Saint George and the Dragon*, 1417. Marble, 39 × 120 cm (15⁵⁄₁₆ × 47¼ in.). Florence, Museo Nazionale del Bargello. Photo: © Alinari/Art Resource, NY.

The frescoes' second level must have been completed when Masolino left in September 1425 for an almost two-year stay in Hungary. Although the two painters collaborated on at least one other occasion, Masolino took no further part in the fresco cycle, leaving Masaccio free, it would seem, to finish it alone. Yet the project was delayed, perhaps for as much as a year and a half. In the meantime, by February 1426 Masaccio had been called away to Pisa, where the Pisa Altarpiece was to occupy him, very likely, for most of the remaining year.

A break in the execution of the Brancacci Chapel frescoes would also account for the marked advance in the lower-level frescoes, which were painted in the following order: *Saint Peter Curing with His Shadow*, *The Distribution of Goods and the Death of Ananias* (both on the altar wall), and *The Raising of King Theophilus's Son and the Chairing of Saint Peter*, which Masaccio never completed. Some sixty years later, Filippino Lippi (1456–1504) added several full-length portraits, at the center of the latter composition and at the far left, as well as the nude figure of Theophilus's kneeling son. Other undocumented frescoes by Filippino flank those by Masaccio on the lower walls.

On balance, the delay in Masaccio's frescoes as of early 1426 may have been due to factors similar to those that led to the eventual, far longer postponement of the project, culminating in Filippino's intervention in the early 1480s. Painters during the Italian Renaissance, by the terms of their contracts, were rarely ever free to interrupt their work for other commitments and were usually bound to firm deadlines. Dilatoriness on this level would hardly have been tolerated by the Carmelite authorities, especially given the didactic nature and timeliness of the frescoes' program. Such delays were more likely due to inadequate funding. That of the Brancaccis may not have been sufficient, requiring fundraising from other sources. (At this time the usually prosperous Felice Brancacci, we learn, was actually short of cash.)[58] One other consideration is that the year 1425 was a particularly troublesome one for Florence, which faced ominous aggression from the north. National security naturally took greater precedence over artistic commissions, whose diminishing number led painters (including Masolino?) to look elsewhere that year for work.

Vasari, who rightly stressed Masaccio's key role in the history of Italian Renaissance painting, wrote that "all the most celebrated sculptors and painters . . . have become excellent and famous" through studying the Brancacci Chapel frescoes.[59] It was there that his art attained a new level of moral grandeur (in keeping with its lofty message) and verisimilitude. This achievement—as both Leon Battista Alberti and his friend, the literary critic Cristoforo Landino, recognized—put Masaccio at the vanguard, a champion of the new art as practiced by Donatello and Brunelleschi, who were in fact our painter's

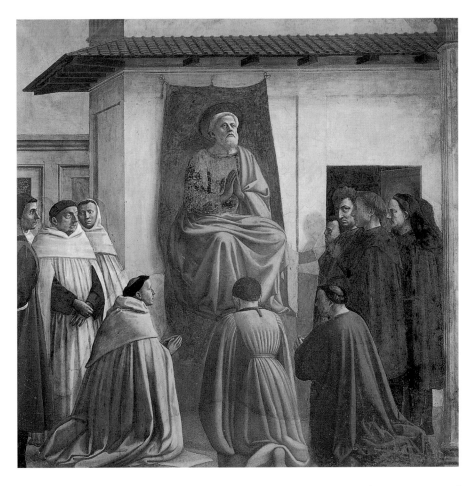

Figure 28
Masaccio, *The Chairing of Saint Peter*, ca. 1427. Fresco. Florence, Santa Maria del Carmine, Brancacci Chapel. Photo: © Scala/Art Resource, NY.

only true masters.[60] Masaccio, wrote Landino, "was an excellent imitator of nature, with great and comprehensive relief, a good composer and pure [in style] without excess ornament . . . he devoted himself solely to the imitation of the truth and to the relief of his figures. He was as sure and good a master of perspective as anyone in those times."[61] Such words accurately describe the sheer accomplishment of Masaccio's *Tribute Money* [FIGURE 26], as well as the inspired later scene of *The Chairing of Saint Peter* [FIGURE 28], in which the painter included likenesses of himself and, possibly, Alberti and Brunelleschi at the far right [see FIGURE 10].

Santa Maria del Carmine was also the site of a monochromatic scene of the church's dedication, which took place on April 19, 1422. Situated over a door leading from the main cloister into the church, Masaccio's *Sagra* (as the fresco

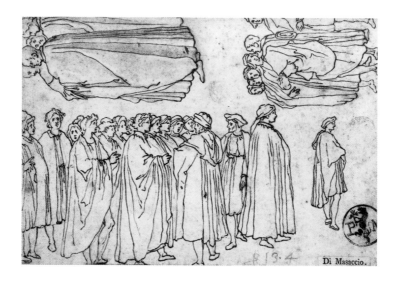

was familiarly called) was demolished sometime in either about 1598–1600 or about 1612. Although its patron is unknown, it may have been the same person who had arranged the actual event, Francesco di Tommaso Soderini. During the 1420s, Soderini was the church's principal benefactor, and his family were patrons of its main chapel.[62] As with the Brancacci Chapel frescoes, *The Sagra* is undocumented, and the fullest early description of it is again that of Vasari.[63] Passing over the actual consecration scene itself, Vasari concentrated instead on the overlapping rows of Florentine citizens—among whom he singled out Brunelleschi, Donatello, and Masolino—assembled in front of the church in Masaccio's composition. According to his account, these were miracles of empirical observation and foreshortening.

Eight drawings, all dating from the sixteenth century, record sections of this great procession. Of these, one outline drawing [FIGURE 29], now in the Folkestone Museum and Art Gallery in Kent, gives the most comprehensive impression, as it includes the greatest number of figures. Most likely, this work is a copy from another one; lacking space at the right, the anonymous draftsman appears to have copied an adjacent section of the fresco in the space on his sheet at the upper left. (The group in the upper right actually replicates a different fresco, by Domenico Ghirlandaio [1448/49–1494].) This same section, with its three monumental figures, probably would have bracketed the procession in Masaccio's mural at the extreme right. With this exceptional composition, "Masaccio can probably be regarded as the inventor of the Renaissance crowd scene. . . . He developed the method of paragraphing a composition, breaking

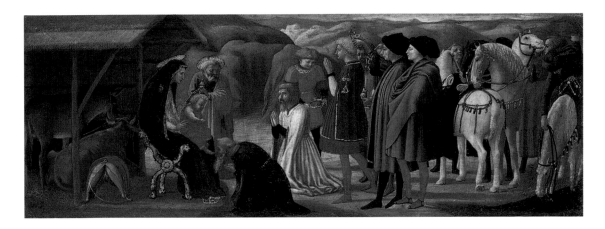

**Figure 30**
Masaccio, *The Adoration
of the Magi*, 1426.
Tempera and gold leaf on
panel, 22.3 × 61.7 cm
(8¾ × 24¼ in.). Berlin,
Staatliche Museen,
Preußischer Kulturbesitz,
Gemäldegalerie (58A).
Photo: Jörg P. Anders.

up what might have been a simple phalanx by setting figures against the pre-
vailing flow, and by dividing his crowd into partly repetitive, partly differenti-
ated, sub-groups."[64]

  Most writers assume that Masaccio, who may have been an eyewitness,
executed the fresco soon after the event of 1422; however, Paul Joannides, not-
ing its advanced style, places it considerably later, perhaps in early 1427 during
the break between painting the middle and lower levels of the Brancacci Chapel
frescoes.[65] Certainly, *The Sagra*'s heroic figures presuppose the monumental
achievement of Masaccio's *Tribute Money* [FIGURE 26]; composition, as recorded
in the Folkestone drawing, also recalls the gathering in the artist's *Adoration
of the Magi* predella from the Pisa Altarpiece [FIGURE 30], which dates from 1426.

  With his next large-scale painting, *The Trinity* fresco in the church of
Santa Maria Novella [FIGURE 31], Masaccio attained a new level of illusionism,
one not seen since antiquity. Here, despite the mural's considerable abrasion
and areas of paint loss,[66] seemingly real figures occupy a classical, trompe l'oeil
architectural setting whose structure has been as precisely calculated as that of
an actual building. The foreground plane recalls a Roman triumphal arch, as
well as one section of the facade of Brunelleschi's Ospedale degli Innocenti, the
architect's first classically inspired building, which was begun in 1419. The
dimensions of the simulated space behind it can be calculated, thanks to the
coffered ceiling, another ancient Roman motif, which Masaccio has ingen-
iously constructed according to the principles of mathematical perspective.
The vertical lines of this grid thus seemingly merge at one point, here locatable

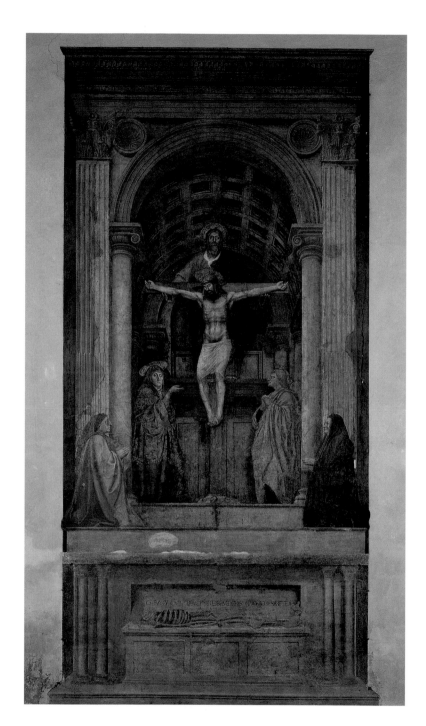

**Figure 31**
Masaccio, *The Trinity*,
ca. 1427. Fresco,
667 × 317 cm (262½ ×
124¾ in.). Florence,
Santa Maria Novella.
Photo: © Alinari/Art
Resource, NY.

at the cross's base. This vanishing point coincides with the eye level of the viewer. To complete the illusion, Masaccio has foreshortened the figures of the Virgin and Saint John the Evangelist, who stand just behind the arch. As in the Brancacci Chapel, the play of light is carefully orchestrated to simulate that issuing from the actual light source, a narrow window above.

Much thought and preparation must have gone into the making of this composition, yet no evidence of any underdrawing, or *sinopie*, exists. Masaccio must have worked instead from a fully detailed preparatory drawing. He also used a module—that of a single coffer, which measures one Florentine *palmo* (29.18 cm)—in orchestrating his scene. Instruction in such sophisticated techniques must surely have come from Brunelleschi, as critics from Vasari on have postulated.[67] Indeed, at the very time that this fresco was under way, Brunelleschi was commissioned to make a eucharistic tabernacle for the church of San Jacopo in Campo Corbellini (since destroyed), whose design as well as iconography may have been the inspiration for Masaccio's *Trinity*.[68] We have already seen how Masaccio's increased precision in rendering classical architecture can be traced to its revival under Brunelleschi. He even appears to have derived his figure of Christ from a sculpture of Brunelleschi's, the carved *Crucifix* likewise in Santa Maria Novella [FIGURE 32].

Not all of the figures in Masaccio's *Trinity* conform to the rules of perspective. In fact, God the Father and, by extension, the other members of the Trinity exist firmly upright and flush with the picture plane, even though the platform on which God stands is set in perspective. (Some two years before, a similar effect had characterized Masaccio's *Healing of the Apostles' Shadow* [FIGURE 24] in the Brancacci Chapel.) With Masaccio, a completely rationalized setting was never accomplished at the expense of his subject matter. It was thus for expressive purposes that he made the Trinity appear to float in space. Here realism is at the service of something visible and yet unseen, for *The Trinity* illustrates, to varying degrees, nothing less than three of the

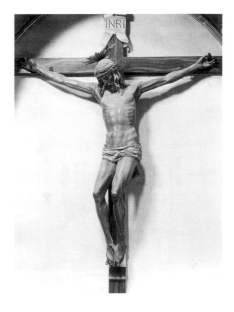

**Figure 32**
Filippo Brunelleschi (Italian, 1377–1446), *The Crucifix*, ca. 1410–25. Painted and gessoed wood, H: 170 cm (67 in.). Florence, Santa Maria Novella. Photo: © Alinari/Art Resource, NY.

central mysteries of the Christian faith: the Trinity, Christ's sacrifice on the cross (with its concomitant promise of human redemption), and the Eucharist.[69]

As with so many of our artist's paintings, *The Trinity* is undocumented. Certainly on stylistic grounds it appears contemporary with the later sections of Masaccio's frescoes in the Brancacci Chapel, which date from 1427 or even early 1428. The fresco's involved setting provides additional support for this view. The simulated skeleton below the main field, with its cautionary inscription ("I was once that which you are, and what I am you also will be"), identifies Masaccio's fresco as a funerary monument, as do the donors in profile who frame the Trinity/Calvary scene. Presumably these kneeling figures were members of the Lenzi family, who were also commemorated by an adjacent tombstone inscribed "Domenico, the son of Lenzo, and his family 1426." Indeed Domenico, who died in 1426, is probably the donor depicted here.

By the time Masaccio completed *The Trinity* in Santa Maria Novella, Masolino had returned from Hungary. Another collaborative project then ensued, probably the most prestigious of the two artists' careers. This involved a double-sided triptych for the major Roman pilgrimage church of Santa Maria Maggiore, the surviving components of which are now divided between the National Gallery in London [FIGURE 33], the Museo Nazionale di Capodimonte in Naples, and the Philadelphia Museum of Art [FIGURE 34].[70] The so-called Colonna Altarpiece was probably commissioned by Pope Martin V (Colonna), who for several years had devoted himself to reviving the artistic glories of the papal city. It represents the first major work of art to be donated to a church in Rome since the late fourteenth century, when rival claims to the papacy had threatened to undermine permanently that institution's prestige.

The Colonna Altarpiece was probably assigned first to Masolino, who may have begun the work as much as four years earlier than the present chronology would at first suggest. Thus, the facial types in the central panels, which depict the miraculous foundation of Santa Maria Maggiore (on the altarpiece's front) and the Assumption of the Virgin (on the back), are closer in style to that of two considerably earlier paintings by Masolino, *The Madonna and Child* [FIGURE 19] of 1423 and the contemporary panel depicting Saint Julian (see above), whose form is repeated in a background figure in *The Foundation of Santa Maria Maggiore*.

Until recently, only one panel from the Colonna Altarpiece, the *Saints Jerome and John the Baptist* in London [FIGURE 33], was said to reveal Masaccio's hand. Other components, such as the *Saints Paul and Peter* in Philadelphia [FIGURE 34], show Masolino at a later stage in his development, that is, at his most Masacciesque. Thanks to a recent technical and critical analysis, however, the

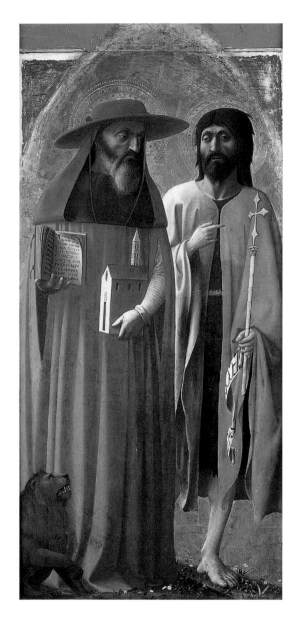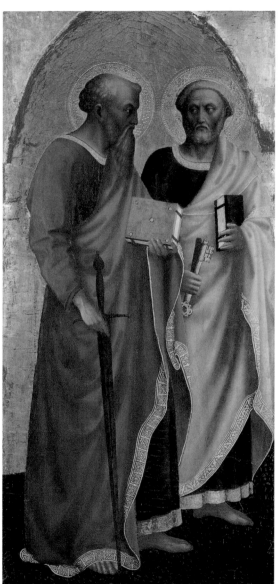

*Saints Paul and Peter* now appears to have been originally designed by Masaccio, who laid in the initial forms and painted the hands of both saints.[71] The Masaccio panel now in London [FIGURE 33], on the other hand, is unfinished in minor sections, such as the torso of Jerome, and in details of costuming.[72] The remaining two side panels of paired saints were completed by Masolino alone. These circumstances and the style of the works themselves lead one to conclude that the London panel is Masaccio's final painting, whose completion was stalled by his untimely death in Rome about June 1428. The purpose of his visit there is unknown, although it very likely involved the Colonna Altarpiece commission. The cause of his death is also unknown, although it probably resulted from the bubonic plague that decimated Rome that summer. Brunelleschi spoke for the eventual outcome of Italian Renaissance art when he is said to have declared that in Masaccio's demise "we have had a very great loss."[73]

# MASACCIO'S PISA ALTARPIECE

The altarpiece that Masaccio made in 1426 for the church of Santa Maria del Carmine in Pisa [see FOLDOUT], which included the Getty Museum's *Saint Andrew*, is the only one of his paintings to be documented. It is also one of only two works by him that can be dated precisely. Still, there are huge gaps in our knowledge of this important polyptych, beginning with the actual painting itself. At least a third of the sum total of the altarpiece's painted area is lost, as is its frame. The art historian must therefore turn to written descriptions of the painting's original appearance. This is the subject of the present chapter, which will also discuss the extant component panels, Masaccio's commission, and other particulars of the polyptych's historical context. And although almost all traces of the original setting have long since disappeared—the Carmelite church in Pisa was renovated soon thereafter—new evidence will be presented regarding the painting's precise location.

The only eyewitness account of the altarpiece in situ is that of Vasari's *Lives*. In the far shorter first edition of 1550, mention of the polyptych is perfunctory. Masaccio, he wrote, "made in the church of the Carmine in Pisa, in a chapel of the rood screen, an altarpiece with an infinite number of figures both large and small, so well arranged and carried out that some that are there appear totally modern."[74] This brief account has all the qualities of hearsay.

Before completing his vastly expanded and revised edition of 1568, however, the biographer, architect, and painter made several visits to Pisa in the course of designing a major architectural site, as well as advising the local cathedral officials.[75] While there, Vasari evidently examined the altarpiece first-hand and thus was able to describe it in far greater detail:

> In the church of the Carmine in Pisa, on a panel that is within a chapel of
> the rood screen, there is a Madonna and Child by his hand, and at her feet

are some little angels sounding instruments, one of whom, playing on a lute, listens attentively to the harmony of that sound. On either side of the Madonna are Saint Peter, Saint John the Baptist, Saint Julian and Saint Nicholas, all very lifelike and vivacious figures. In the predella below are scenes from the lives of those saints, with little figures, and in the center are the three Magi offering their treasures to Christ; and in this part are some horses portrayed from life, so beautiful that nothing better can be desired; and the men of the court of those three Kings are clothed in various costumes that were worn in those times. And above, as an ornament for the said painting, there are many saints around a Crucified Christ on several panels.[76]

The second written source for Masaccio's Pisa Altarpiece is the account book of the donor, Ser Giuliano di Colino di Pietro degli Scarsi (1369–1456), a prosperous notary from the San Giusto parish district of Pisa. This ledger is incomplete and is supplemented by a later digest in his hand that provides additional data.[77] A signed contract between Masaccio and Ser Giuliano for the altarpiece is also mentioned but is now lost. Drawn up by the local notary Ser Pietro di Benenato da San Savino, it was dated February 19, 1426, the same day that Masaccio actually began work on the altarpiece.[78] Together, these documents provide a wealth of detailed information on the painting's background, its relation to the church itself, and the builders, stone carvers, and other painters involved. The records also provide a partial picture of Ser Giuliano himself, his family, and their prestige and devotional needs, which will be the basis for a later chapter. But before reconstructing the setting for the altarpiece, it is necessary to first consider the individual painted components that have survived.

The central panel of the Virgin and Child, with the music-playing angels that impressed Vasari, is one of the treasures of the National Gallery, London [FIGURE 35]. Both of its sides have been cropped, enough to remove any trace of a possible *barbe*, that area along the edges of the panel's painted surface that would have been covered by the frame. (The *barbe* survives in the upper section of the panel, in the shape of a Gothic arch.) The bottom of the picture seems to have been cut down more severely. Accounting for the missing area of the music-playing angels' feet and what was probably an inscription, an estimated 25 centimeters may have been removed from the bottom of the London panel.[79] The paint surface has also suffered. There is considerable abrasion in the figure of the Christ child and the Virgin's face, and her transparent veil is now only barely visible. Old areas of inpainting have discolored and the gold leaf is very worn.

Nevertheless, the majority of this image remains intact. The composition is dominated by the monumental figure of the Virgin, who is earthy rather than beautiful or refined. As in certain sections of the Brancacci Chapel fres-

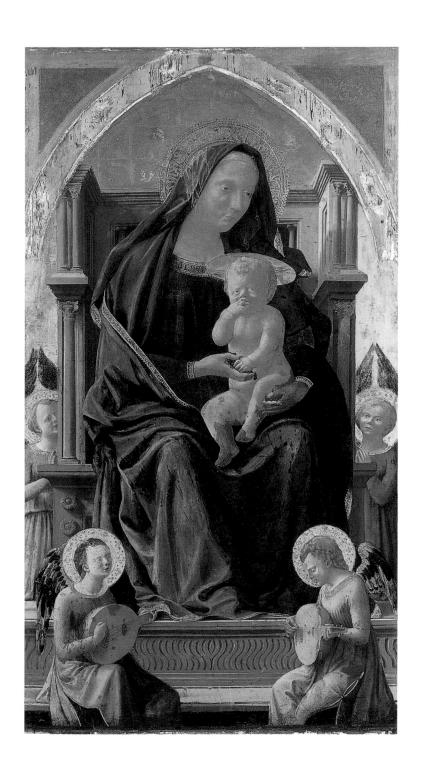

coes—left incomplete, as we have seen, by late 1425—a strong light models the forms, while almost no surface decoration distracts from the figures' bold presence. Here again Masaccio's mature style is altogether evident.

Set within a traditional Gothic arched field, Masaccio's *Madonna and Child with Four Angels* [FIGURE 35] brilliantly orchestrates the suggestion of space. As in the San Giovenale Triptych of 1422 [FIGURE 12], the artist has inserted a large architectural throne with two goals in mind: to minimize the area of gold leaf, which served a decorative, antirealistic function, and to enhance the sculptural mass of the seated Virgin. Like *The Trinity* fresco of about one year later, the application of architectural detail not only sets off the monumental human forms, it also allows one to measure space. The throne thus barely contains the seated Virgin; the parts of her body that emerge—the top of her head and her lap—are emphasized by the powerful light source emanating from the left.

The flanks of the throne allow us to calculate the composition's vanishing point, which, unusually for this date, lies just below the Virgin's knees. This very low position, which in the Renaissance came to be determined by the viewer's eye level, enhances the monumental impression of the Godhead. So do the two praying angels at rear —identifiable by their colored garb as a cherub (in blue) and a seraph (in red) — both of whom are partly obscured by the massive throne.

Masaccio's vertical placement of the haloes emphasizes the varying planes of his composition.[80] The one exception is the aureole of the Christ child, which is set in deep perspective.[81] Roughly aligned with the second cornice of the throne, it defines his own spatial area, even as the outline of this figure is set protectively within the diamond shape of the Virgin's blue cape and sloping left arm.

It is in the illusion of space—the whole spatial envelope, as defined by the accurate play of light—and in the amplitude of his forms that we recognize the extent of Masaccio's formal achievement. As fascinating as his earlier renditions of the theme are, it is the central panel of Masaccio's Pisa Altarpiece that truly announces the nascent Renaissance style. And at the core of Masaccio's composition is one of the most keenly observed, natural renditions of the Christ child in the entire history of art.

As with his earlier depictions of the theme, Masaccio's *Madonna and Child with Four Angels* testifies to the continuing authority of Giotto's *Ognissanti Madonna* of about 1310 [FIGURE 16]. Yet the types here are different, less abstracted and cool; not only are Masaccio's central figures more homely and real, but their body proportions are more like actual ones. A significant influence, according to one author, was Arnolfo di Cambio's statue of the Virgin and Child [FIGURE 36], which in Masaccio's day was displayed over the central portal of Florence cathedral.[82] This work, the sculptural equivalent of Giotto's painting, offered a model

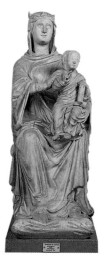

**Figure 36**
Arnolfo di Cambio (Italian, first documented 1266, d. ca. 1310), *The Madonna and Child*, ca. 1296. Marble, H: 174 cm (68½ in.). Florence, Museo dell'Opera del Duomo. Photo: © Alinari/Art Resource, NY.

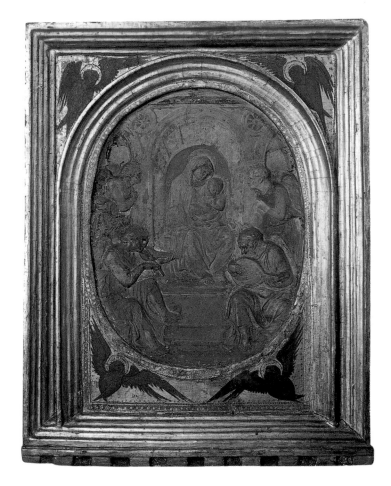

**Figure 37**
Attributed to Donatello,
*The Madonna and Child
with Four Angels*, ca.
1420–25. Polychromed
stucco in original frame,
H: 38.5 cm (15⅛ in.).
New York, Michael Hall
Fine Arts. Photo: © 2001
American Bible Society.

of pronounced solidity, with an energy in the drapery folds and an indifference
to physical beauty in the case of the Virgin Mary that could well have inspired
Masaccio.

   As in many instances throughout Masaccio's oeuvre, the sculptor Dona-
tello had a profound effect on the appearance of the London *Madonna and Child*.
Even before the painting's rediscovery in 1906, Vasari's description of the Pisa
Altarpiece (specifically, that of the lute-playing angels) had led one art historian
to note its central composition reflected in a small relief known in several ver-
sions [FIGURE 37].[83] Since then Donatello's authorship of the composition has
been generally accepted, with an important proviso: that the relief actually pre-
dates Masaccio's altarpiece.[84] The prominent steps and the grouping of the
Virgin and Child, not to mention the two foreground angels, functioned as a
springboard for Masaccio's invention. We have already seen how, in a similar

way, another Donatellesque relief had inspired the painter's *Tribute Money* from the previous year [FIGURE 26]. There, too, Masaccio had taken one exception to Donatello's overriding naturalism, by enlarging the central figures' scale. He furthermore reduced the size of the two foreground angels in the London panel, thereby enhancing the relative importance of the Virgin and Child.

Donatello's composition is closely related in style to several other reliefs by the master that date from the early to mid-1420s. The lute-playing angel at the left, for example, recalls a figure in *The Feast of Herod*, which was commissioned for the baptismal font of the Siena Baptistery in 1423 and completed two years later. The head of the Virgin is especially close to that in a relief of *The Assumption of the Virgin*, which Donatello carved in late 1427/early 1428 as part of the tomb of Cardinal Rainaldo Brancaccio. That project, undertaken in partnership with Michelozzo, was executed in the studio that the two sculptors maintained in Pisa, beginning in the very year that Masaccio worked there on his altarpiece. The close personal association of Donatello and Masaccio should in any case be assumed. In fact, the sculptor even received one payment for the Pisa Altarpiece on the painter's behalf, most likely in settlement of a debt, of which Masaccio had many.[85]

An additional piece of evidence connects Donatello's relief with *The Madonna and Child with Four Angels*. One other person who received payment on Masaccio's behalf at Pisa was his brother and (at the time) assistant, Scheggia.[86] In an unpublished panel dating from about 1430 [FIGURE 38], Scheggia included the familiar device of the two foreground angels, borrowing equally from Donatello and Masaccio. There the second angel from the left mimics its equivalent in the relief and plays the same instrument, a viola da braccio. Scheggia's seated angel playing a lute, on the other hand, derives from that at the lower right in the painting by Masaccio.

We have already mentioned the remarkably fluent and confident handling of the Virgin's draperies in the London *Madonna* [FIGURE 35]. Here again Donatello's example must have served as a catalyst, for the deep folds, especially at the left, recall those of the sculptor's *Jeremiah* [FIGURE 39], which was completed in June 1425 for the bell tower of Florence cathedral.[87]

One final source for the London *Madonna and Child with Four Angels* bespeaks a key feature of early Renaissance art, the rediscovery of ancient sculpture and architecture, of which Donatello and Brunelleschi, along with Ghiberti, were the keenest early artistic exponents. The wavy, vertical incisions, known as strigillation, marking the front of the top step depend on a traditional Roman sarcophagus design, of which examples are recorded at Pisa during Masaccio's lifetime. To simulate this type of sculptural relief was exceptional at this early stage in the history of Italian painting, when more complex surface

**Figure 38**
Giovanni di Ser Giovanni, called Scheggia (Italian, 1406–1486), *Madonna and Child with Eight Musicmaking Angels*, ca. 1430. Tempera and gold leaf on panel, 31.5 × 25.5 cm (12⅜ × 10¹/₁₆ in.). London, Christie's, December 11, 1992, lot 2. Photo: © 2003 Christie's Images Ltd.

**Figure 39**
Donatello, *Jeremiah*, 1423–25. Marble, H: 191 cm (75¼ in.). Florence, Museo dell'Opera del Duomo. Photo: © Alinari /Art Resource, NY.

 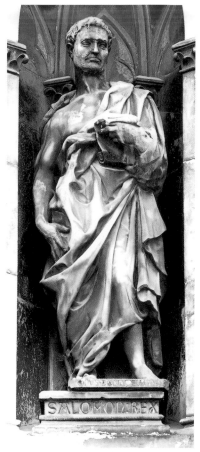

patterns were preferred. Masaccio's strigillation may also have had a more contemporary source, for the motif appears as a frieze on Brunelleschi's Ospedale degli Innocenti, begun in 1419. From the same building Masaccio seems to have derived the particular type of composite Corinthian capital that decorates the Virgin's throne.[88] As for the paired inset columns on the upper level of this same piece of furniture, the motif cannot be traced in any fifteenth-century architecture, although it likewise appears on certain Roman sarcophagi. As paired pilasters, however, they decorate the above-mentioned Cardinal Brancaccio monument by Michelozzo and Donatello.[89]

Above *The Madonna and Child with Four Angels* would have been *The Crucifixion* now in Naples [FIGURE 40], a reconstruction confirmed by the wood grain and pattern of wormholes on the back of both works, which indicate that both compositions were painted on the same panel support.[90] In no other compo-

sition does Masaccio attain such high-pitched expression-ism, which is in complete accord with his subject matter. He arranges the four figures with a stark, almost geometric clarity. The attenuated forms of the Virgin and Saint John bracket this scene "like blocks of human granite petri-fied by sorrow."[91] Far more abstract, even flat, is the figure of Mary Magdalene, who kneels with her back to the viewer with plaintive arms outstretched like a receptacle for Christ's blood. Here there is only one distraction: Christ's head, which has rightly been described as "an ambitious fail-ure."[92] Intending to compensate for the panel's original high placement, Masaccio attempted to foreshorten the figure of Christ by omitting his neck. The experiment failed since, incongruously, Christ's head appears parallel to the picture plane, an effect enhanced by the placement of his halo. Masaccio learned from this error, though, when he returned a year later to the related subject of *The Trinity* fresco in Santa Maria Novella [FIGURE 31].

Vasari's eyewitness account of the Pisa Altarpiece described "many saints around a Crucified Christ on several panels." Given the known width of the extant painted base, or predella, we can calculate that these components depict-ing single saints would have numbered four. Of these, only two survive. The Getty Museum's *Saint Andrew* [FIGURES 1, 9] would have originally stood on the upper level at the ex-treme right [see FOLDOUT]. There the saint would have brack-eted the row of figures nicely. Moreover, his upward gaze, following the horizontal bar of his own cross, would have been directly aligned with Christ's head in *The Crucifixion*.[93]

Judging from the pose of the *Saint Paul* at Pisa [FIG-URE 8], in all likelihood that panel stood just left of *The Crucifixion*, where the saint's relatively narrower girth and the vertical strands of his robes at right echo the drapery design of the grieving Saint John [FIGURE 40]. Saint Paul's drapery is anything but static. That and the placement of his arms are a loose amalgam of similar features found in two Donatello statues made for the campanile of Florence cathedral: the *Jeremiah* [FIGURE 39] and the slightly later *Habakkuk*, which by Vasari's time had been nicknamed *Zuccone*, or "pumpkin head" [FIGURE 41]. Because the *Saint*

Figure 40

Masaccio, *The Cruci-fixion*, 1426. Tempera and gold leaf on panel, 82.1 × 63.5 cm (32⁵⁄₁₆ × 25 in.). Naples, Museo Nazionale di Capodimonte (36). Photo: © Scala/Art Resource, NY.

Figure 41

Donatello, *Habakkuk* ("*Zuccone*"), ca. 1426/36. Marble, H: 195 cm (76¾ in.). Florence, Museo dell'Opera del Duomo. Photo: © Alinari/Art Resource, NY.

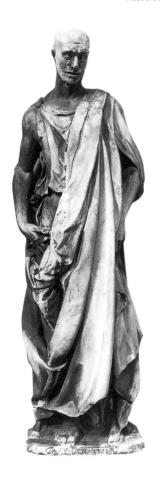

47

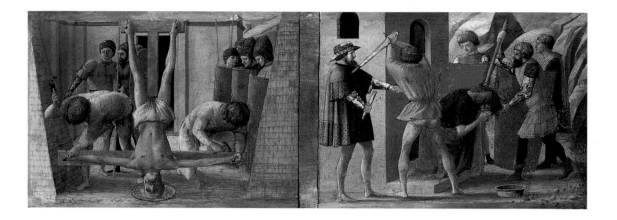

*Paul* formed part of the upper zone of Masaccio's altarpiece, the problem of fore-shortening was key here. Quite clearly, Masaccio responded to the challenge by examining Donatello's solution of depicting two draped figures seen from below.

All three parts of the painted bottom section, or predella, are displayed at the Gemäldegalerie in Berlin. Typical of Italian altarpiece design, the predella panels depict narrative scenes that relate to the subjects of the main field above. Beneath the central image of *The Madonna and Child with Four Angels*, now in London, was originally *The Adoration of the Magi* [FIGURE 30]. Just to that panel's left, it was previously assumed, were *The Martyrdom of Saint Peter* and *The Martyrdom of Saint John the Baptist* [FIGURE 42], separated by a vertical band of gold leaf; in the corresponding position at the right was said to have been *Saint Julian Killing His Parents* and *Saint Nicholas Dowering the Three Daughters* [FIGURE 43] with a similar divider. This proposed sequence followed Vasari's description of the four saints depicted immediately above—Saints Peter, John the Baptist, Julian, and Nicho-las—which was presumed to read from left to right. Because each scene was painted on separate wooden panels and not on one continuous plank, as was customary with predella construction, there seemed to be no compelling physi-cal evidence, such as a contiguous pattern of wood grain, to confirm the order of Masaccio's two side predella panels.

Thanks to a recent in-depth study of the technical aspects of Masac-cio's and Masolino's art, this apparent order should be reversed.[94] According to this report, if the Saint Julian/Saint Nicholas predella panel were placed at the left and the Saint Peter/Saint John the Baptist predella at the right, the dis-tribution of nail holes (marking the original attachment of predella panels to vertical battens that anchored them to the main part of the altarpiece) would be regular. Were this order reversed, the distribution of nail holes would be irregular. With this new hypothetical arrangement, the saints in the privileged position,

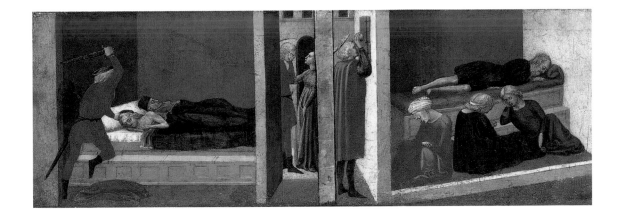

**Figure 43**
Masaccio and assistant, *Saint Julian Killing His Parents; Saint Nicholas Dowering the Three Daughters*, 1426. Tempera and gold leaf on panel, 22 × 62 cm (8 11/16 × 24 3/8 in.). Berlin, Staatliche Museen, Preußischer Kulturbesitz, Gemäldegalerie (58E). Photo: Jörg P. Anders.

at the Virgin's right, would thus have been Saints Julian and Nicholas. Such a placement would be logical since Saint Julian was the donor's patron saint. Moreover, his companion, Saint Nicholas, was the protector of Ser Giuliano's parents, whose given names, Colino and Cola,[95] are diminutives of Nicholas. As for the paired saints originally at the right, Saint Peter would have owed his inclusion here to his role as an emblem of the Church and as a onetime visitor to the region; he also was the patron saint of Ser Giuliano's paternal grandfather, Pietro degli Scarsi. As for the Baptist, he was the primary patron saint of Florence, which had had dominion over Pisa since 1406. He was also particularly venerated by the Carmelites (see below).

The combined length of all three predella panels (about 220 cm, accounting for missing framing elements) provides an approximate width for the entire altarpiece. Given the known dimensions of the central panel in London, we can roughly calculate the width of each of the flanking panels of two saints each. This would allow for two panels of saints in the zone over each of the two side panels [see FOLDOUT]. Nothing is known of the appearance of the latter pictures, nor of the subject of the missing companion panels to the *Saint Andrew* and the *Saint Paul* above. Yet, given the facts of the painting's original location and its donor, we can hypothesize which other saints Masaccio depicted in this zone. One, for example, may have been James (*Jacopo*), in honor of Ser Giuliano's wife, Jacopa di Francesco di Bandino.[96] This leaves us with one other missing saint, perhaps Mark in honor of Ser Marco, Giuliano's young and recently deceased cousin, and the figures of Saint Paul (along with Peter, the papacy's patron saint) and Saint Andrew. Andrew's presence is unexplained, although in similar contexts he sometimes accompanies his brother Saint Peter as the first two apostles called by Christ. He may also owe his appearance here to being the name saint of Jacopa's sister Andreuccia, who likewise had married a notary.[97]

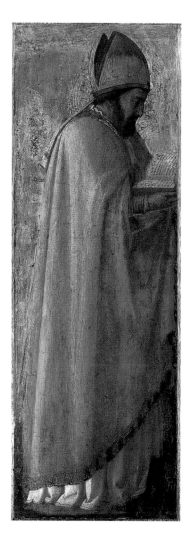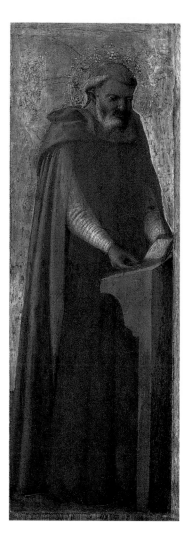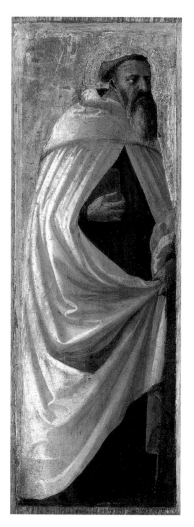

The final surviving panels depicting individual saints are four, far smaller sections, which in all likelihood formed part of the altarpiece's two pilasters [see FOLDOUT]. These show Saint Augustine [FIGURE 44], Saint Jerome [FIGURE 45], and two saints in Carmelite garb [FIGURES 46, 47]. At least two other pilaster panels made up this particular section, and they would have depicted the other two Latin doctors of the Church, Saints Gregory the Great and Ambrose.

In contrast to these and other parts of the Pisa Altarpiece, Masaccio excluded all gold-leaf background from his predella scenes, which signaled a notable advance in naturalism. In *The Adoration of the Magi* [FIGURE 30], the three

kings have dismounted from their richly caparisoned horses to pay homage to the chubby Savior, who is extended toward the eldest king by the enthroned Virgin in profile. Bracketing this action to the right are two elfin, secular figures in contemporary dress. They probably are the polyptych's patron, Ser Giuliano degli Scarsi, and his fellow notary and first cousin once removed, Ser Marco di Marco di Nero degli Scarsi.

Despite its small size, *The Adoration of the Magi* is one of the masterpieces of Italian Renaissance painting. Its closest comparison in Masaccio's oeuvre is *The Tribute Money* fresco [FIGURE 26] of roughly one year before. As in that work, a gathering of figures stretches across the front of a believable outdoor setting, and a background of mountains and hills highlights each participant or individual group in relief. Here again we can presume that Masaccio employed mannequins set in a strong raking light as a compositional aid, since the precise location of almost every figure can be determined accurately. The naturalism of Masaccio's style is again remarkable, as seen in the beautifully observed animals and in details such as the saddle at the left, set in perspective. Yet even in this revolutionary composition, the painter reveals a debt to the local artistic past—the Virgin and Child were probably inspired by a statue of this subject by Giovanni Pisano and his shop [FIGURE 48], which in Masaccio's day capped the dome of the Pisa Baptistery.[98] And the motif of the grazing horse has been traced to the carved figure on Nicola Pisano's pulpit in that same building.[99]

What sets this composition apart from all of Masaccio's other paintings, though, is the orchestration of color. Note, for instance, the subtly modulated range of blues, set at regular intervals across the composition. The other prominent hue is a vermilion, recalling that of the supine Magdalene figure in *The Crucifixion* above. Such colors never overwhelm; rather, they are at the service of the central, holy drama.

This aspect is also apparent in the scene of the Baptist's execution, in which the same color highlights the pitiful, kneeling victim [FIGURE 42]. Masaccio isolated

**Figure 48**
Giovanni Pisano and workshop, *Madonna and Child*, ca. 1268–78. Marble, H: 190 cm (74¾ in.). Pisa, Baptistery. Photo: Opera della Primaziale Pisana.

each individual against his particular backdrop, yet with brilliant economy of means he has integrated all of the action to relate a pungent, gripping tale. A case in point is the two figures at the left. A powerfully lit officer in profile gives the order, his left hand extending into the adjacent dark background. Nearby, the executioner twists his upper body to the left, the tip of his tensed sword seemingly striking his superior's chest. A truly miraculous representation of potential energy, this figure exudes the same tactile sense of movement as the shivering youth in *Saint Peter Baptizing the Neophytes* [FIGURE 25]. The main line formed by this executioner creates a V with the handheld spear at the right, while trapped between these two axes is the proffered head of the Baptist. In both martyrdoms, the finality of the deed and its routineness are emphasized by the artist obscuring all of the executioners' faces and, in the case of *The Martyrdom of Saint Peter*, by increasing their relative size.

Compared to the other sections of Masaccio's predella, that formerly at the left [FIGURE 43] comes as a singular letdown. That this panel belonged with the two other components, though, there can be no doubt, especially as the two scenes have the same type of gold-leaf divider as the paired martyrdoms in Berlin. In all likelihood, Masaccio assigned the execution of this panel to an assistant, a typical timesaving tactic of the time. Masaccio's deadline was, in any case, fast approaching. On October 15 he pledged Ser Giuliano to undertake no other work so as to finish his painting on schedule.[100]

As we learn, on that date one assistant, the twenty-year-old Scheggia, received payment for his brother. Later, on December 18, a second, unnamed assistant was recorded in the same capacity.[101] On December 24, two days before the final payment to Masaccio, a third helper, Andrea di Giusto, did likewise.[102] Had he executed the panel with Saints Julian and Nicholas according to the master's design? No paintings by Andrea survive from the late 1420s for purposes of comparison. However, the style of his later work—aside from the occasional borrowing from Masaccio—does not recall that of the panel in Berlin. Nor does the latter show an affinity with Scheggia's known oeuvre, all of which in any case dates later. Presumably, Masaccio's task here was instead relegated to the second, unnamed, assistant cited on December 18.

As it happens, a fourth assistant took part in the Pisa Altarpiece's execution, Fra Filippo Lippi (ca. 1406–1469). He had grown up in the neighborhood of Santa Maria del Carmine in Florence and in 1421 had taken his vows as a Carmelite friar there. Given this calling, he was under no obligation to join the local painters' guild. Thus, even though he is first listed as a painter only in 1430, he could very well have been active in this second profession perhaps some five years earlier.[103] One recent article has proposed that Lippi executed another minor section of Masaccio's Pisa Altarpiece, namely the panel in Berlin depict-

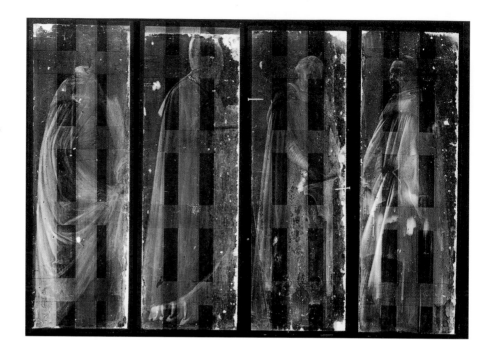

ing an unidentified, clean-shaven Carmelite saint [FIGURE 47].[104] The stylistic arguments for this attribution are convincing. To begin with, the rubbery physiognomy, the greater contrasts of light and shade, and the wispier, even eccentric, rendition of various drapery folds are at odds with the style of the three other pilaster panels now in Berlin [FIGURES 44–46]. These differences are even more pronounced when the handling of paint in all four works is examined using X-radiography [FIGURE 49]. On the other hand, all of the features mentioned above invite comparison with one of Lippi's earliest paintings, a painted gable now in Milan, which probably was made for a site in the Carmine church in Florence [FIGURE 50].

The *Clean-shaven Carmelite Saint*, formerly attributed to Masaccio, thus becomes Lippi's earliest extant work. Moreover, there is evidence to suggest that even in his home base of Santa Maria del Carmine—where strict legislation limited any friar's access to the secular world[105]—Fra Filippo again assisted Masaccio. Several of the heads in the Brancacci Chapel fresco *The Raising of King*

*Theophilus's Son*, which was executed after Masaccio's return from Pisa, have that same expressive intensity so noticeable in Lippi's early works.[106] Just possibly, it was Fra Filippo's participation here that led to the choice of his son Filippino to finish the Brancacci Chapel frescoes more than fifty years later.[107]

There is no documentary proof of Lippi's presence in Pisa in 1426; perhaps he executed this part of the Pisa Altarpiece in Florence instead. Still, Carmelite friars often traveled between the order's various houses, and Lippi was far from an exception. In 1426 alone, he made brief visits to the monasteries in Siena and Prato, where he is documented on August 17 and 29, respectively.[108] Later that year, when the deadline for Masaccio's altarpiece approached, he may have hastened to Pisa to assist the older painter. Such a journey is likely since, according to Vasari, Lippi even painted a fresco of a bishop saint in Santa Maria del Carmine, an otherwise unrecorded work that is long since lost.[109] Further evidence that Lippi indeed worked at Pisa is the impact that Masaccio's retable, or raised shelf above the altar, had upon Fra Filippo's independent oeuvre, a subject we will return to shortly.

At this point, each of the surviving components of Masaccio's Pisa Altarpiece has been identified and described. What of the assembled altarpiece itself? At least nine hypothetical reconstructions of its original layout have been made,[110] yet such is the paucity of evidence, both technical and literary, that none of them can be called definitive. In 1966 Shearman deduced from the lack of any *barbe* on either side of the London *Madonna and Child with Four Angels* [FIGURE 35] that the central panel and the lost side panels formed one continuous open space [FIGURE 51].[111] He furthermore noted the presence of one long cast shadow on top of each of the London panel's simulated steps, implying that the latter feature continued the entire width of the altarpiece's main section. The lowest of these two shadows, he also concluded, marked the baseline of the uppermost left-hand saint, while the other figure would have stood on the level below (that section of the panel that has been cropped) and further to the left.

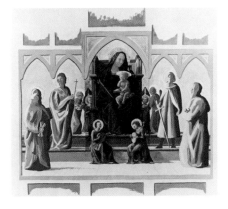

**Figure 51**
Masaccio,
*The Pisa Altarpiece*
(reconstruction
by John Shearman, in
*Burlington Magazine*
108 [September 1966],
p. 457).

To Shearman, this radical solution to the problem of depicting an enthroned
Virgin and Child in the company of full-length, standing saints seemed worthy
of an innovative master like Masaccio, who departed so often from precedent.
Only the scale of the Virgin and Child and the Gothic arch of the central panel,
which Shearman hypothesized was repeated over each of the flanking saints
(thereby marking off each predella scene below), recalled traditional altarpiece
design. Otherwise, Masaccio's polyptych opened the way to the rectangular field
altarpiece championed by Alberti and exemplified by such later works as *The
Saint Lucy Altarpiece* of Domenico Veneziano [FIGURE 52].

A 1977 study by Gardner von Teuffel, which supplies rich historical
background in terms of patronage, iconography, and the history of altarpiece
design, takes issue with Shearman's proposed reconstruction. She pointed out
that Masaccio in all likelihood had not designed the frame. In this period it usu-

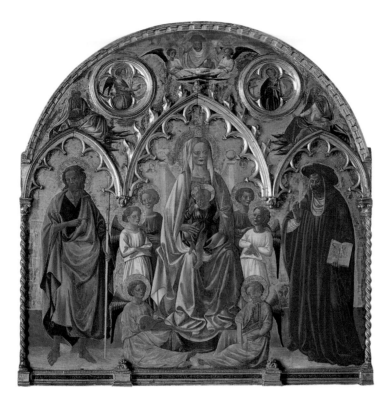

ally was made by an independent carpenter or framemaker.[112] This work sequence appears to be corroborated by the summary of expenses later recorded by Ser Giuliano. Thus payment to the framemaker (eighteen florins), one Antonio di Biagio da Siena, immediately followed that for work on the patron's chapel and preceded that to Masaccio for the painting (a total of eighty florins).[113] After that came a record of a payment to Antonio di Biagio for the wooden predella (three lire, ten soldi).[114] Gardner von Teuffel's conclusion was that Masaccio, far from being the prime mover in avant-garde compositional design, had rather to make do here with a preexisting, traditional tripartite format in which the side panels were separated visually from the London *Madonna and Child* by preapplied frames. Further evidence for this proposal, she maintained, is the compressed space at either side of the throne, resulting partially in the vertical placement of the angels' wings at rear. Such crowding would not have made visual sense had the altarpiece's main field been undivided.

Against such reasoning, two objections can be made. In an intact altarpiece [FIGURE 53] that reflects several of the innovations of Masaccio's Pisa Altarpiece, the central figures are similarly hemmed in at the sides by attendant angels, and yet no framing elements separate this area from that of the flanking

**Figure 53**
Francesco d'Antonio
(Italian, 1393/94–last
documented 1433), *The
Madonna and Child with
Saints John the Baptist
and Jerome*, ca. 1430.
Tempera and gold leaf
on panel, 182 × 168 cm
(71⅝ × 66⅛ in.).
Avignon, Musée du Petit
Palais (M.I.431).
Photo: © Réunion des
Musées Nationaux /
Art Resource, NY. Photo:
R. G. Ojeda.

57

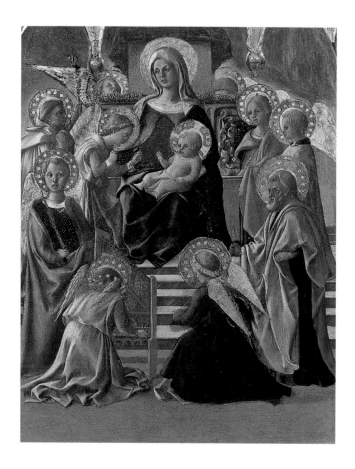

saints.[115] Moreover, several Tuscan altarpieces with a unified central field capped by three successive Gothic arches can be traced back to the late fourteenth century. Masaccio easily could have known two of these, one by Agnolo Gaddi and one by the Sienese master Taddeo di Bartolo (1362–1422).[116]

A second objection is that according to iconographic precedent, the wings of a cherub and a seraph are aligned vertically and meet together over each holy figure's head. This feature is thus not a consequence of simple overcrowding.[117] In formal terms, it echoes the vertical thrust of the two central framing pendants in Shearman's reconstruction [FIGURE 51], in which, originally, neither the cherub nor the seraph was cropped at its outermost side.

For the above reasons, Shearman's reconstruction of the main section of Masaccio's altarpiece does seem the more persuasive. Besides the example of Francesco d'Antonio's derivation now at Avignon [FIGURE 53], two other, slightly

58

later compositions lend credence to this view. One is a small yet monumental picture [FIGURE 54] by the young Filippo Lippi, who, we have seen, traveled to Pisa and even executed a part, albeit a minor one, of Ser Giuliano's altarpiece.[118] In all points—such as the strong, directional light and monumental figures—this painting is Masacciesque. Our interest lies in its parallels with the Pisa Altarpiece as reconstructed by Shearman. The two share the arched upper frame terminating in pendants and the expanse of steps that extends across the composition's entire width.

Especially close to Lippi's Empoli painting, and by extension Masaccio's Pisa Altarpiece, is a newly discovered panel [FIGURE 55] by Borghese di Piero, whose oeuvre until recently was assigned to the so-called Master of Saints Quirico and Giulitta.[119] Though mostly active in Lucca, Borghese did work intermittently in his native Pisa. Thus the year after Masaccio completed his altarpiece for Ser Giuliano, Borghese made some painted banners for Pisa cathedral. And in March 1430 he formed a contract with a local painter (originally from Florence) known as Cola d'Antonio (1393–after 1467), who had painted the altar frontal for Ser Giuliano's chapel in the Carmine.[120] Borghese's own connections with the local Carmelites went back even further: in 1398, his father, Piero di Borghese, completed a (since-destroyed) fresco for that very church.

In contrast with Shearman's hypothesis, that of Gardner von Teuffel claimed that Masaccio inherited the template of a traditional framed polyptych and so played no part in the altarpiece's frame design, which may have had to conform to the more conservative demands of its patron. Paul Joannides, on the other hand, has proposed a compromise solution, in which Masaccio would have revised the original design of the altarpiece's main section.[121] This operation may have consisted of simply removing the colonettes that were to separate the side panels of paired saints from the central panel, thereby providing a unified main field. After all, the application of colonettes *over* the picture plane to act as separate framing elements was common to traditional altarpiece design and did not intrude on the panels themselves. Joannides's reasoning is both convincing and suggestive. He also seconds Shearman's view that the innovation of a single-field central section, which proliferated as of about 1430, could only be due to a revolutionary painter such as Masaccio.

Perhaps at one time there existed records of payments to Antonio di Biagio for such later revisions to the frame of the Pisa Altarpiece. In fact, only one documentary reference itemizing Antonio's contribution survives from Ser Giuliano's account book, and that is for a later piece of church furniture.[122] Instead, the carpenter's work on the panels themselves, the predella, and the altar frontal (see below) are recorded in three summary disbursements that

form part of our second documentary source for the altarpiece, the later digest of payments recorded by Ser Giuliano. Masaccio's payments over a period of ten months are amply documented, on the other hand, in Ser Giuliano's account book. Numbering eight, they can be summarized as follows: (1) February 20, 1426 (first payment), 10 florins; (2) March 23, 15 florins, 60 lire; (3) July 24, 10 florins; (4) October 15, 25 florins; (5) November 9, 3 lire; (6) December 18, 1 florin; (7) December 24, 30 grossi; and (8) December 26 (final payment), 16 florins, 15 soldi.[123]

As for the layout of the polyptych's uppermost level, the lack of physical evidence precluded any convincing reconstruction attempt—until recently. Examining the Naples *Crucifixion* [FIGURE 40], Roberto Bellucci, Carl Strehlke, and others have taken note of a horizontal cavity, 11.5 centimeters high, extending along the top of the picture's reverse. It would have held a thick beam or cross batten, an integral part of early Italian altarpiece design that connected adjacent panels and aligned them. Two cross battens also once ran along the back of the London *Madonna and Child with Four Angels* in the center, connecting this part with the missing side panels of standing saints. The indication of a third batten at the top of the polyptych's central section provides "a very important clue about the original shape of the Pisa altarpiece. The batten on *The Crucifixion* would not have been needed if it did not join other elements at the same height of the altarpiece."[124] In this case, then, Masaccio's polyptych could not have terminated in freestanding pinnacles, as has been generally supposed, but must have had a square or rectangular shape instead. In overall outline, at least, it would have anticipated the Renaissance *pala* as championed by Alberti.

But what would the panels flanking *The Crucifixion* have looked like? Vasari's description of this uppermost level as containing "many saints around a Crucified Christ on several panels" implies the presence of the *Saint Paul* and the Getty Museum's *Saint Andrew*, but these and undoubtedly the two lost companion panels are not as tall as the extant *Crucifixion*. Besides, placed over the side sections of the main register, these shorter panels would probably have had a lower baseline than that of the Naples painting. For these and other reasons (see below), Strehlke has even eliminated the *Saint Paul* and the *Saint Andrew* as components of the Pisa Altarpiece.[125] According to him, the batten marks from these two works (consisting of two horizontal incised lines, rather than the usual horizontal cavity) could not possibly line up with that of the Naples *Crucifixion*. Other objections are the comparatively narrow depth of each panel (an original thickness of 2 cm), the smoothness of each panel's reverse (in contrast to the raw, unfinished state of the other component sections), and the suggestion that both the *Saint Paul* and the *Saint Andrew* originally terminated in a rounded, as opposed to a Gothic, arch.

Here it should be pointed out that Sienese frame-makers, such as Antonio di Biagio in the case of the Pisa Altarpiece, were more apt to combine Gothic-shaped and rounded arch frames than their Florentine equivalents.[126] The main flaw in Strehlke's argument, however, is his mistaken notion that the two panels were attached to a larger complex by means of cross battens at all.[127] Although the function of the incised lines on the reverse of the Pisa and Getty panels eludes us, the two pictures' physical properties—their narrow thickness, smooth reverse, and rather random placement of nail holes applied during the fashioning of the panels themselves—argue instead that both panels were applied over a carpentry backing rather than affixed laterally to some other components of an altarpiece.

It is here proposed (following the suggestion of Laurence Kanter) that the batten affixed to the top of the Naples *Crucifixion* joined up with the back of two flanking panels set *over* the level comprising the Pisa and Getty panels. Their subjects would most likely have been the Annunciate Angel and the Virgin Annunciate, which had iconographic precedents in polyptychs by such early fifteenth-century Tuscan painters as Lorenzo di Niccolò (act. 1392–1412), Lorenzo Monaco, Giovanni dal Ponte, and Starnina.[128]

It is now time to turn to the question of the original site for Masaccio's altarpiece. Related documentation for the chapel, as well as on-site inspection at Santa Maria del Carmine [FIGURE 56], allow one to reconstruct its setting. Here, though, it is necessary first to consider the church and its parish. Santa Maria del Carmine is located along the main artery of Chinzica, that section of Pisa forming the south bank of the Arno River that, according to one early fifteenth-century account, was considered "the most beautiful" of its four *quartieri* [FIGURE 57].[129] In Ser Giuliano's day, this major route led north to the city's main bridge and then to the east of the famous cathedral precincts. The church was constructed between 1324 and 1328, when a certain Donato Carratella was prior. Before that, the Carmelite church and monastery had been located outside the city walls to the west, at a place called

**Figure 56**
Façade, Santa Maria del Carmine, Pisa. Photo: E. Rowlands.

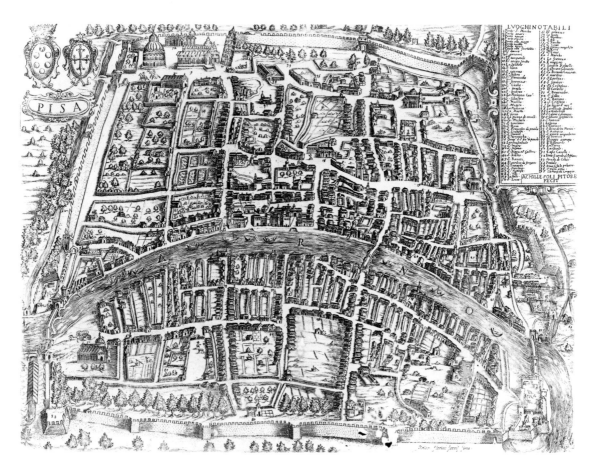

**Figure 57**
Achille Soli (Italian),
*Map of Pisa*, early
1600s. Engraving, 39 ×
52 cm (15⅜ × 20½ in.).
Florence, Biblioteca
Nazionale Centrale.
Courtesy Ministero
per i Beni e le Attività
Culturali della
Repubblica Italiana.

Caffaggio (present-day Barbaricina). This move into Pisa was in itself signi-
ficant. It typified the order's commitment, beginning in the mid-thirteenth
century, to an increasingly urban mission — in the manner of the great Fran-
ciscan and Dominican mendicant orders — rather than to a life of monastic
detachment.

      Although not large compared to the city's churches of San Francesco
and Santa Caterina — belonging to the Franciscan and Dominican orders, respec-
tively — the Carmine must have served its constituency well even in this mo-
ment of Pisa's precipitous decline. The church's plan was essentially the same as
that of today [FIGURES 58, 59], only perhaps somewhat shorter.[130] It was in the
shape of a long rectangle with altars lining the side walls, with three chapels
along the building's eastern side. The largest of these chapels, that at the center,
housed the high altar. Just to the west of this area would have been the friars'
choir, which was separated from the rest of the nave (and thus the congregation)

by a rood screen. It was along this structure, known in Italian as a *tramezzo*, that Vasari specified the site of Masaccio's Pisa Altarpiece.

The tramezzo was a regular feature of mendicant and monastic churches in Italy until the Counter-Reformation in the last third of the sixteenth century. Consisting of two parallel transverse walls, it segregated the friars or monks from the laity and was pierced by an arch along the nave's central axis. There were usually altars attached to the tramezzo, which in some cases included a second story. The tramezzo was thus a wider and altogether more substantial structure than that signified by the English term "rood screen"; this amplified meaning is suggested by its alternative name in Italian, *ponte*, or bridge. Although

several such double-walled rood screens survive in northern Europe (as in West-minster Abbey and in the church of Saint Etienne-du-Mont in Paris), seemingly none remain in Italy to this day.[131] Still, a vivid illustration of a tramezzo in an imaginary Italian church [FIGURE 60] can be seen in a painting by the Domini-can friar, architect, and painter Fra Carnevale (act. 1445–d. 1484). However, this tramezzo is in the latest Renaissance style, which would not have been the case in Santa Maria del Carmine, where the architectural idiom was either Gothic or Romanesque.[132]

If we could see the right side of Fra Carnevale's imaginary tramezzo, we would have an approximate idea of what the original location of Masaccio's altarpiece looked like. According to a notice of Ser Giuliano dated November 29, 1425, what he called "my chapel" was attached to the right side of the church's tramezzo, with Masaccio's polyptych facing the congregation. According to his inelegant description, the site was "in the nave of this church in front of the choir, that is with its back to the choir, extending from the door, that is from the entrance to the choir, up to the side wall of the church on the south side."[133] Masaccio's implied light source in the Pisa Altarpiece conforms with the actual flow of light in that location, as it enters the church through the windows on the north nave wall.[134] Had the painting originally stood in the chapel to the right of the choir—that is, further east beyond the tramezzo—this synchro-nization of lighting, both painted and real, could not have occurred.

The probable location of the church's tramezzo, and by extension Ser Giuliano's chapel, can now be plotted for the first time. Examining the Car-mine's northern elevation (that bordering the Via del Carmine), Francesco Quin-terio has detected between the second and third windows a vertical break in the brickwork that may indicate the spot where the transverse walls of the early tramezzo originally met the outside wall.[135] Turning to the church's interior, this break lies on the same axis as a gap in the old network of tomb slabs that patterned the floor prior to a radical rearrangement in about 1870 [FIGURE 59]. That the tramezzo may well have been there is also attested by one other aspect of Dario Angiolini's floor plan. With the tramezzo in place, the door leading to the friars' cloister would have been segregated from the laity, as was the case at the Carmelite church in Florence.

The chapel itself was ordered, according to a lost contract of Novem-ber 29, 1425, from the local stone carver and mason Pippo di Giovanni da Ghante. According to one document, it had above "a cross-piece in marble with columns of white marble, high enough to cover a panel over the altar."[136] Construction materials consisted of "white Carrara marble, iron joints, lead and every other thing one needs to make a vault, namely two cross-pieces above, two and a half columns of white, milky marble from Carrara . . . above an altar."[137] Ser Giuliano's

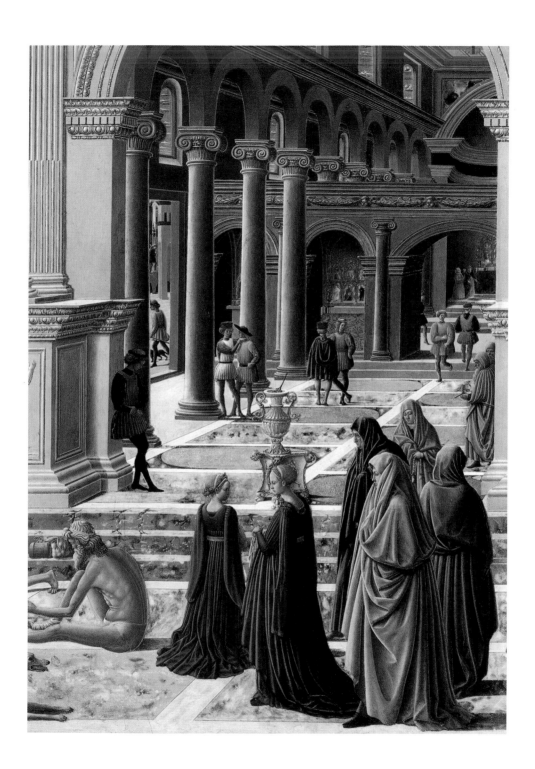

**Figure 61**

Dragomanni Chapel,
Arezzo, San Domenico.
(Reproduced from
*Jahrbuch der Berliner
Museen: Jahrbuch der
Preussischen
Kunstsammlungen Neue
Folge* [Berlin, 1977].)

chapel, in other words, would have have been capped by a single groin vault, which was supported by two columns at front and a pair of half columns at back, the latter being attached, no doubt, to the tramezzo itself. The actual construction was carried out by a mason known as maestro Bartholomeo di maestro Tomeo da Montemagno. The finished work measured at least 8⅔ *braccia*, or about 5.11 meters, high. Its width was about half that amount, which is just a bit more than the base of Masaccio's altarpiece.[138] A small and very shallow chapel, it probably resembled a structure like that of the Dragomanni family chapel in San Domenico, Arezzo [FIGURE 61], which dates from 1370. Termed a "canopied wall altar,"[139] it proved especially popular throughout Italy from the early fourteenth century on. Finally, to proclaim his patronage, Ser Giuliano had his coat of arms emblazoned over the chapel's entryway on the front of the vault.[140]

The vault itself was completed by March 10, 1427, that is, three months after Masaccio received final payment for the altarpiece.[141] Work on the struc-

ture continued until June 1428, while final payments extended until the following April.[142] Any chapel, by definition, functions as the prescribed site of prayers and above all the Mass, and that of Ser Giuliano was no exception. Besides Masaccio's altarpiece, which must have been installed only after the painter's death, there was the altar itself, for which payment was made to Pippo di Giovanni and "Bartholomeo di Pardo maestro" on June 5, 1428.[143] Also listed is an "altar frontal with covering above" made by the carpenter "Maestro Bartholomeo [di Angelo] da Siena."[144] This was painted "with a deep red, very beautiful . . . with a fringe surrounding" it and, at the center, a half-length image of the donor's patron saint, all of which was executed by Cola d'Antonio, a minor Florentine painter who, on at least one occasion, had received payments from Ser Giuliano on Masaccio's behalf.[145] Giuliano's disbursements for painting the curtains that covered Masaccio's altarpiece are also itemized as the work of one Mariano di maestro Piero della Valensana.[146] Finally, there was a wooden altar step for communicants for which payment was made on July 23, 1428, to Antonio di Biagio da Siena, the same artisan who had made the frame and predella panels for Masaccio's altarpiece.[147]

Inside Ser Giuliano's chapel there were several wooden seats, including one reserved for the donor himself. The stonemason Pippo di Giovanni supplied three ornamented paving stones next to the chapel entrance and the rest of the pavement, which was inlaid with brick.[148] On Ser Giuliano's instructions, his tomb slab, which Pippo di Giovanni began to construct on March 26, 1414, was moved from its original site "in the actual middle of this church" to a spot in front of his new altar, placed somewhat to the side.[149] By 1433 this site included the bodies of Ser Giuliano's parents, his sister Mona Bacciamea, his first cousin once removed Ser Marco, his daughter Nanna, and two other women, Teccia and Lucretia, whose relationship to Ser Giuliano is unknown. Ser Giuliano himself was buried there in 1456.

Ser Giuliano's chapel in Santa Maria del Carmine was not (as we have noted) large, but its cost was considerable. On July 27, 1428, the patron ceded the Carmelites some land, the rental income of which went to maintain the altar in good order.[150] The whole project involved a rather large cast of masons, builders, woodworkers, and painters, including Masaccio. As detailed above, the role of the stone carver Pippo di Giovanni was central to the enterprise, and for his efforts he received a total of 140 Florentine florins. Masaccio, as we have seen, earned 80, which was the mid-range price for an altarpiece at this time.[151]

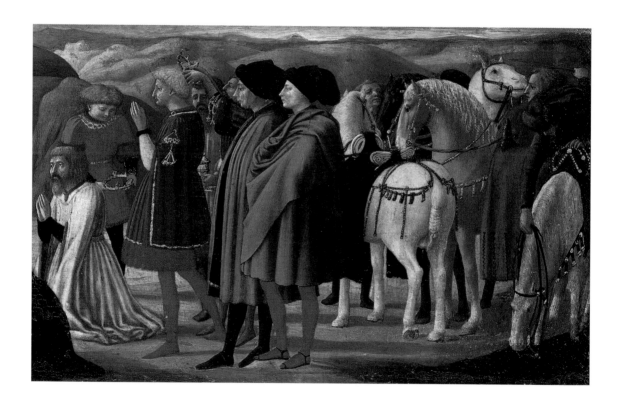

**Figure 62**
Masaccio, *The Adoration
of the Magi*
[detail of Figure 30].

# SER GIULIANO AND THE CARMELITES:
# THE PATRONAGE OF THE ALTARPIECE

According to the Renaissance architect, sculptor, and writer Filarete (ca. 1400–ca. 1469), a work of art was born of two factors: the creative artist, whom he called the mother, and the patron, who played the role of the nurturing father.[152] An excellent illustration of the patron's enabling function appears in the central predella of Masaccio's altarpiece [FIGURE 30]. There Ser Giuliano, who paid for the altarpiece, and (most likely) Ser Marco, his first cousin once removed, stand prominently at center right, flanking the procession of adoring Magi. In profile, as was common with donor portraiture at the time, they approach the Virgin Mary and the newborn Christ child.

In subtle ways, though, Masaccio has set the two family members apart. Placed clearly in the foreground picture plane, Ser Giuliano and his cousin do not appear to make eye contact with the holy figures; they neither kneel nor even gesture toward them, as traditional donor likenesses were wont to do. Their isolation is further highlighted by the pattern of light and dark on the ground. They stand on a path of light that leads to the Magi in the next plane [FIGURE 62], while to the left and right lie large patches of dark shadow. Unlike the surrounding participants, strangely enough, Ser Giuliano and Ser Marco barely produce shadows. A final differentiating feature is their dress. The two notaries are the only figures wearing hats, a situation that only highlights the ritual removal, occurring nearby, of the youngest king's crown. The plainness and relatively neutral color of their capes also serve to distinguish them from the opulently dressed Magi nearby. As a final touch, Masaccio emphasizes the figure closest to the viewer with a brilliant flourish of drapery that engulfs Ser Marco's hands, a detail borrowed from antique sculpture.[153]

At first, then, Ser Giuliano and Ser Marco appear to form part of the Magi's procession, but they are rooted instead in the temporal world. Such a distinction was typical of sacred images at the time.[154] Still, by having himself

inserted next to the Adoration scene, Ser Giuliano seems to imply that his own gift-giving parallels that of the three Magi: all four had humbly, and yet magnificently, offered tribute to the newborn Christ. For the rich donor, therefore, the Magi functioned as a collective advocate or patron saint. Such specialized devotion led to the establishment of confraternities dedicated to the Magi in Florence, Milan, and elsewhere in Renaissance Italy. Moreover, in commissioning works of art, individual members frequently turned to the Adoration of the Magi as an appropriate subject. Then, to commemorate their part in the creative process, the same patrons—as in the Berlin *Adoration* predella—had themselves depicted among the throng. By sponsoring such imagery, Ser Giuliano must have hoped that his own lavish gifts—a chapel in Santa Maria del Carmine graced with Masaccio's altarpiece—would guarantee him and his recently deceased cousin, as well as the rest of his family, a place in paradise.

On earth, Ser Giuliano di Colino di Pietro degli Scarsi was clearly a man of stature. His family, unlike the vast majority of the population at this time, was of sufficient prominence to have acquired a surname. The addition of "da San Giusto" to their name was probably made in order to distinguish them from the noble and politically active Scarsi family from Porta a Mare, who were exiled after Pisa's annexation by Florence and who were not related.[155] Though little is known of Giuliano's father, Colino (died 1417), he was evidently a man of property. Giuliano's own career began in 1386/87, when, at age eighteen, he joined the notaries' guild. In 1404 and again in 1418 he acquired land. Later, according to the Florentine tax assessment, or *catasto*, of 1428/29 (first extended to Pisa that year), he declared a net worth of 497 florins.[156]

A gregarious man, Ser Giuliano played an active part in politics. In November and December 1421 he served as one of two priors (members of the highest local office) for the Chinzica quarter of the city, a position he assumed again in September and October 1430.[157] Some five years later, on January 10, 1435, the prosperous notary was elected to the prestigious Opera, or board of works, charged with the governance and maintenance of Pisa cathedral. This was a fitting honor for a man in his mid-sixties at the end of a long and successful career. It also bespoke considerable diplomatic skill, for, like a Talleyrand *avant la lettre*, Ser Giuliano had endeared himself to a succession of regimes: from the governments of Jacopo d'Appiano, Gian Galeazzo Visconti, and the Bergolini faction to that of the pro-Florentine Gambacortis and (following the city's fall in 1406) the Florentine republic itself.[158] Ser Giuliano's new post of *operaio* also attested to his experience in sponsoring building commissions.

In the patriarchal society in which he prospered, Ser Giuliano had one drawback. He was without a male heir; his only child, Giovanna (1409–1423),

had died young. Nevertheless, the two sons of his uncle, Nero di Pietro degli Scarsi, each produced a son who went on to become a notary like the family hero, Ser Giuliano. The latter, by his own admission, sponsored each of his notary cousins, taking pride in their youthful accomplishments. One of these cousins must be the figure in matching dress behind Ser Giuliano in *The Adoration* predella [FIGURE 62]. He cannot be Ser Pietro di Dino di Nero degli Scarsi, as he was born the very year that Masaccio painted the Pisa Altarpiece.[159] He must instead be Ser Marco di Marco di Nero degli Scarsi, who had trained in Ser Giuliano's shop in the parish of San Sebastiano before matriculating in the notaries' guild in 1418. His notarial records, like Ser Giuliano's, survive, though only for the following two years.[160] Tragically, the youthful Ser Marco (we do not know his birthdate) died of the plague in 1420. Masaccio's image would thus have been a posthumous one, commemorating the patron's beloved family member and protégé.

Other Pisan notaries had attained prominence before the Florentine annexation.[161] Indeed, the profession's importance in Italian society from the early Middle Ages onward cannot be overstated, given the advanced stage of Italian civic, social, and economic life, in which so many exchanges necessitated written contracts.[162] Notaries had their own guilds, often in concert with judges, and they frequently prospered. (The fathers of Masaccio, Brunelleschi, and Saint Antoninus, archbishop of Florence, were all notaries.) They also commissioned works of art, both collectively and individually. In 1425, for instance, Gentile da Fabriano (ca. 1370–1427) executed a now-lost fresco for the Sienese guild of notaries; it was an influential work, especially given its very public location facing the city's Piazza del Campo.[163] A far more private commission is represented by Cenni di Francesco's small panel of Saint Jerome in his study, in which the donor—a notary from the patrician Ridolfi family of Florence—sits at the lower left with writing implements in hand [FIGURE 63].[164]

During times of war, economic downturn, and political oppression, the demands for a notary's services

**Figure 63**
Cenni di Francesco di Ser Cenni (Italian, act. ca. 1369–ca. 1415), *Saint Jerome in His Study*, ca. 1380. Tempera and gold leaf on panel, 32.4 × 21.9 cm (12¾ × 8⅝ in.). Private collection. Photo: Wildenstein and Co., Inc., New York.

diminished. This was especially the case after Pisa, already suffering profound economic and political decline,[165] was acquired by Florence in 1406. As a consequence, the ranks of notaries steadily shrank: from 119 in 1402, to 90 in 1412, to a mere 69, according to the *catasto* of 1428/29. By that time, about half of their numbers had withdrawn to the countryside or were forced to take on additional work. To exacerbate their woes, the ruling Florentines gave preference, especially in the matter of government contracts, to their own notary class.[166]

In the case of artistic commissions, too, Florentine rather than Pisan artists now had their pick of the work. Although the moment was not propitious for artistic funding of any sort, painters from Florence now competed successfully for local projects, since they no longer were required to join the Pisan painters' guild in order to practice locally.[167] Thus Masaccio was not the first Florentine painter to receive local commissions after Pisa's ignominious fall. Lorenzo Monaco, for instance, is said to have executed images of the Madonna and Child for the local Camaldolese monastery of San Michele in Borgo.[168] A few years later, Lorenzo's pupil Francesco d'Antonio provided an altarpiece for the church of San Domenico, a work now divided between the Kress Collection at the Denver Art Museum and the museum in Pisa.[169] Although Gentile da Fabriano, the most celebrated Italian painter of his day, is not known to have traveled to Pisa, his *Madonna and Child* (Museo Nazionale e Civico di San Matteo, Pisa) may have been commissioned by the local bishop, the Florentine Alamanno Adimari (1362–1422). Gentile provided the frescoed decorations for Adimari's tomb (later destroyed) in Santa Maria in Vallicella, Rome.[170] Another Florentine painter, Bicci di Lorenzo, whom we have seen had links with Masaccio, provided a *Saint Eulalia* for another private chapel in Santa Maria del Carmine, datable on stylistic grounds to about 1430.[171] Other Florentine painters active in early-fifteenth-century Pisa included Paolo Schiavo (1397–1478), a follower of Masolino, and Giovanni Toscani (1370/80–1430). Yet, of all the Pisan projects assigned to Florentine artists, none ranked as high as Masaccio's altarpiece for Ser Giuliano.

At this point, it would be natural to ask how a successful notary in a conquered and devastated town could have lured Masaccio to Pisa. Ser Giuliano maintained good relations with his Florentine overlords, traveling at intervals to the capital, where he may have learned of Masaccio's fame. On the painter's part, there would have been ample incentive to leave Florence, since, beginning in 1425, artistic patronage had shrunk because of the grave financial and political crises that gripped the city.[172] Other artists of the first rank were similarly affected. Uccello, for instance, headed to the Veneto for work late in the summer of 1425, and Masolino, Masaccio's partner in executing the Brancacci Chapel frescoes, left for Hungary that September.

Sometime in late 1425 or early 1426, well before Masaccio came to Pisa, Donatello, a colleague and friend, appears to have established a subsidiary studio with his partner, Michelozzo di Bartolomeo (1396–1472), in the Chinzica quarter of Pisa, that district especially favored by Florentines and the site of Santa Maria del Carmine.[173] Later, when both sculptors were in Pisa, Donatello must have associated with the young painter, since he was present during one of Masaccio's payments from Ser Giuliano. Perhaps it was even he who had recommended Masaccio for the commission. After all, the young master had already distinguished himself with the Brancacci Chapel frescoes (then under way) in the even grander Carmelite center in Florence. With Masolino now gone and their joint project there interrupted, Masaccio could hardly have resisted the major opportunity represented by Ser Giuliano's commission. Besides, in his short, albeit meteoric, career the painter was ever in need of funds, as his tax declaration reveals and as his nickname, Sloppy Tom, might suggest.

All of the circumstances leading to Masaccio's commission must be examined and imagined if we are to understand the forces operating at the moment of creation, including the patron's association with the Carmine church. With the young painter available and Ser Giuliano's funds now in place, work would have begun on the altarpiece for the notary's chapel. Yet the association of Ser Giuliano with the Carmelite church, which dates to as early as 1414,[174] has so far remained unexplained. In all of the extant documents he is listed as a member of another parish, that of San Giusto in Canniccio, as were several of the witnesses cited in the payments for his chapel and its decoration.[175] The church of San Giusto, located south of Pisa, was a dependency of San Martino, which, like Santa Maria del Carmine, lay in the Chinzica district. Yet these first two churches belonged to the (Augustinian) Canons Regular, not to the Carmelites.[176]

What, then, induced Ser Giuliano to build his burial chapel in Santa Maria del Carmine? Here it is worth noting that one of his wife's brothers, Fra Piero di Francesco di Bandino, was a friar at this same Carmelite church and is so described in Ser Giuliano's testament of March 27, 1450.[177] According to this document—presumably the final will of the patron, who died six years later—the church was the prime legatee of Ser Giuliano's movable goods. Listed among those who would serve as executors of his estate were the prior of Santa Maria del Carmine (whoever that would be at the time of death) and three other Carmelite friars: the above-mentioned Fra Piero di Francesco di Bandino, Fra Pietro di Dino di Nero degli Scarsi (a cousin), and Fra Giuliano di Antonio Aliotti. Unfortunately, nothing more is known about this brother-in-law of Ser Giuliano or his two fellow friars.

As we will demonstrate, the altarpiece for the Carmine church in Pisa was not the product of just a mother/artist (Masaccio) and a father/patron (Ser Giuliano). There was another contributing factor, namely the Carmelite order in Tuscany. The painting's existence, it turns out, was part of a far-reaching development in which Carmelite centers in Florence, Siena, and Pisa gained in importance, even as they hosted unusually innovative altarpieces and frescoes. The impetus behind these commissions, however, is obscure. No documents attest to any sustained strategy from on high. Instead, the evidence is derived from the works of art themselves and from the history of their commissions. But before discussing these items (of which paintings by Masaccio form the most sublime component), we must first learn something about the Carmelite order.

According to the Carmelites' so-called Doctrine of Origin, the order had been founded by the Old Testament prophet Elijah, who, as the spiritual ancestor of monasticism itself, had withdrawn to the desert to fast and pray.[178] It thus predated all other monastic or preaching orders, and Christianity as well. The first Carmelite community was established in the Holy Land when several holy men first settled in the ruins of the ancient Fountain of Elijah on the slopes of Mount Carmel. A miraculous vision of the Virgin Mary there eventually inspired a special devotion to the "Virgin of Mount Carmel."

This version of the order's antiquity was vigorously propagated throughout the fourteenth and fifteenth centuries.[179] Yet the actual date of its establishment was much later. Its first rule, or founding charter, was composed by Albert, the papal legate and patriarch of Jerusalem, between 1206 and 1214.[180] The rule was then confirmed on January 30, 1226, by Pope Honorius III, who prescribed the monks' distinctive white mantle. The spread of Carmelite centers from the Holy Land to Europe led to a mitigation of the rule by Pope Innocent IV on October 1, 1247. According to that papal bull, the mission of the Carmelite order was expanded from its original eremitic tradition to embrace a more active, apostolic role that included pastoral visits, charitable deeds, and preaching. In emulation of the mendicant and preaching orders, such as the newly established Franciscans and Dominicans, the Carmelites were now called friars and were allowed to settle in cities.[181] Then, in 1317, Pope John XXII issued a bull granting the order the same rights as the other preaching communities. The friars were now responsible only to the order's superiors and to the pope. One result of such legislation was that the Carmelites became ardent supporters of the papal party, especially during the fractious next century.

The first Carmelite settlements in Europe tended to be in cities that had close links with the Holy Land and that had served as embarkation points for the Crusades, such as the port cities of Pisa and Genoa, as early as 1249 and

1258, respectively. In Tuscany, the number of settlements—such as those of Florence (founded 1248/49) and Siena (founded sometime before 1261)—grew to such an extent that a Tuscan provincial chapter was incorporated in 1324.[182] This chapter met once a year, usually on June 24, the feast day of Saint John the Baptist, the patron saint of Florence. Fortunately for our purposes, records of these meetings survive for the period of 1375 to 1491, and these provide a fascinating overview of local Carmelite activity.[183] They also tell us much about two leaders of the Carmelite monastery in Pisa during the time of Ser Giuliano's commission: Fra Antonio di Matteo, its prior, or head, who hailed from Pisa, and the subprior, Fra Bartolomeo d'Ulivieri, from Florence.

Fra Bartolomeo and especially Fra Antonio appeared many times as witnesses to payments by Ser Giuliano for his chapel in Santa Maria del Carmine and his altarpiece by Masaccio.[184] In fact, approval of the project in its various stages and in its entirety was left to the prior. When, for instance, the stone carver and mason Pippo di Giovanni worked on the chapel itself, he was charged to "make it very beautiful in its design, according to the agreement of maestro Antonio, prior of the Carmine."[185] Similar phrasing accompanies Masaccio's final payment of December 26, in which Ser Giuliano records how the altarpiece was deemed "complete, to the agreement of said maestro Antonio."[186] That occasion took place in the chapter house of Santa Maria del Carmine in Pisa, in the presence once again of Fra Antonio.

Besides holding the position of prior, Fra Antonio was a master of theology, having studied the subject for three years in Cologne and then for another three years in Florence.[187] Given such training and experience, not to mention his rank, he may well have played a part in supervising the content of Masaccio's altarpiece. Such a scenario seems plausible in regard to the central panel now in London [FIGURE 35], where the symbolism of the grapes presented by the Virgin and avidly devoured by her son has been related to Carmelite texts and imagery. The fermented juice of this fruit is a well-known metaphor for the blood that Christ shed on the cross, as established at the Last Supper and commemorated in the Mass. A specifically Carmelite addition to this iconography is the order's identification of the Virgin with the vine, as in the Carmelite text "O Flower of Carmel, O blossom-bearing vine, child-bearing glory to the heavens, gentle mother so unique, free of carnal knowledge of any man of Carmel. Grant our prayers, [O] Star of the Sea."[188] This prayer figures prominently in the liturgy of the principal Carmelite feast day, that of the Virgin of Mount Carmel, which takes place on July 16. The association of the vine with the Virgin and the grape with her son also informs other works of art produced, like the Masaccio, for a Carmelite setting [FIGURE 64].[189] There was thus a certain tradition to the

Marian iconography proposed for Masaccio's central panel and devised most
likely by the prior, Fra Antonio. Such Carmelite images affirmed the Virgin's
central role in God's plan for salvation.

The iconography of the saints, on the other hand, appears straight-
forward, at least in the predella scenes, which depict typical episodes from the
figures' lives. As for the choice of saints, one of them, Saint John the Baptist,
may owe his inclusion here not only to his being Florence's leading patron saint
but also to his veneration by the Carmelites, who saw in him a successor to Eli-
jah.[190] Otherwise, only minor sections of the altarpiece, the two pilaster saints in
Carmelite garb now in Berlin [FIGURES 46, 47], make direct reference to the order.

Fra Bartolomeo, the subprior of the Pisa monastery for most of the
years from 1413 to 1428, also witnessed payments to Masaccio. Because he came
from Florence and had served as subprior of the Carmelite house there in 1412,[191]
he has sometimes been said to have recommended Masaccio as the painter of
Ser Giuliano's altarpiece.[192] Yet nothing more is known about Fra Bartolomeo,
who was perhaps a relation of the Olivieri family from Florence. Instead, we
must direct our attention to the links between the Carmelite house in Pisa and
that in Florence.

All of the evidence suggests that both monasteries were very closely
connected. First of all, personnel were frequently transferred between the two

establishments. Besides the example of Fra Bartolomeo, there was the prior of the Pisa house in 1418, Niccolò di Lippo, who was likewise a Florentine and who, four years later, became prior of the Carmelite settlement in Florence.[193] During the 1420 meeting of the Tuscan provincial chapter, which was held in Pisa, the subprior of the host monastery was another Florentine, Fra Giovanni di Biagio.[194]

In 1422, 1424, 1425, 1426, and 1428, the meetings of the Tuscan provincial chapter of the Carmelite order took place in Florence. This was understandable given the city's prominence, as well as the importance for the spiritual and intellectual life of all Tuscan-based Carmelites of the *studium*, or study center, which was based in the Florentine monastery. Members of the Pisa house, especially Fra Antonio and Fra Bartolomeo, would thus have had ample opportunity to see the important cultural and artistic developments then taking place in Florence.

At Santa Maria del Carmine itself, the most remarkable annual event was the festival marking the Ascension of Christ. A special play was presented, with fantastic stage props devised by Brunelleschi and scenery such as that designed in 1425 by Masaccio's colleague Masolino.[195] Indeed, the Tuscan provincial chapter meetings in 1424, 1426, and 1428 all took place in Florence on that same feast day. On those occasions Fra Antonio and Fra Bartolomeo must surely have seen the Ascension play.[196] They also would have viewed Masaccio's and Masolino's frescoes in the Brancacci Chapel. Several of the frescoes there include Carmelite figures bearing witness to the apostolic events and so confirm the order's vigorous role in championing papal primacy. With Masaccio's name thus bound to the glory of the order, perhaps then and there the decision was made to employ the same painter in the more provincial center of Pisa to execute Ser Giuliano's altarpiece.

Carmelite imagery had developed in the region of Tuscany, beginning almost a century before Masaccio's Pisa Altarpiece was created. Representations of the prophets Elisha and Elijah and of various Carmelite saints proliferated. Narratives from Carmelite history were also depicted, in several cases by some of the most progressive artists of the day. Thus a paradox developed, for in championing the antiquity of their order, Carmelite patrons often sponsored some of the most modern imagery around.[197] Masaccio's altarpiece is an example of that tendency.

The Carmelite altarpiece par excellence is that of Pietro Lorenzetti, which was completed in 1329 for the church of San Niccolò del Carmine in Siena [FIGURE 65].[198] As it was made for the high altar and paid for by the Carmelites (and later also by the city), it represents a more official commission than one for

a side chapel, which a private patron usually sponsored. Thus the saints selected for the main register of Lorenzetti's altarpiece are emblematic of the religious order and bespeak the church's dedication, in contrast to a privately produced retable, such as Masaccio's painting for Ser Giuliano, in which the choice of saints reflects a more personal devotion. The predella scenes for Lorenzetti's altarpiece are also far more programmatic; indeed, they represent the most comprehensive account of Carmelite events in the history of Italian panel painting.

Another image of early Carmelite history was made for the main cloister of the Carmine church in Florence by the young Carmelite follower of Masaccio, Filippo Lippi [FIGURE 66].[199] Detached from the east wall in 1939 and transferred to its present site in the monastery's bookstore, the fresco dates from a few years

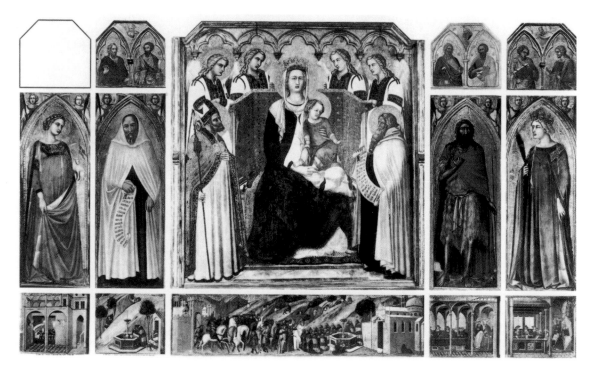

**Figure 65**
Pietro Lorenzetti (Italian, act. ca. 1320– 1348), *Madonna and Child with Saints*, completed 1329 (reconstruction after C. Volpe, *Pietro*

*Lorenzetti* [Milan, 1989], p. 136). Tempera and gold leaf on panel, approx. 165 × 330 cm (65 × 130 in.) overall. Siena, Pinacoteca Nazionale (I.B.S.n.16a) (central panel);

(84, I.B.S.n.16b83) (predella); (62,64) (two upper segments, at left); (578) (*Saint Agnes*); (579) (*Saint Catherine of Siena*); Pasadena, Norton Simon Museum (*Saint Elisha* and *Saint*

*John the Baptist*); and New Haven, Yale University Art Gallery (1959.15.1) (upper segment to right of central panel).

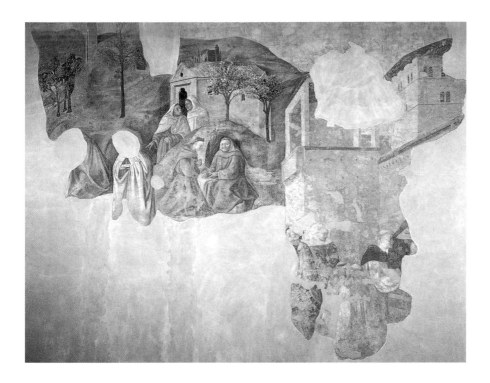

Figure 66

Fra Filippo Lippi, *Scenes from Early Carmelite History*, ca. 1428–30. Detached fresco. Florence, Santa Maria del Carmine. Photo: © Scala/Art Resource, NY.

after Lippi's earliest surviving painting, the pilaster panel of a clean-shaven Carmelite saint that he executed for Masaccio's Pisa Altarpiece [FIGURE 47]. The fresco's upper scene appears to represent monks in their more ancient, eremitic life on Mount Carmel. While some figures there wear the earlier, striped habit, those placed closer to the viewer bear the familiar white mantle that was approved only in 1286. The damaged section at the lower right—a gathering of ecclesiastics outside a city wall—is even more difficult to identify. Does it represent "a Pope confirming the rule of the Carmelites," as Vasari supposed?[200] Unfortunately, not enough of this section of the mural survives to identify the scene.

Adjacent to Lippi's fresco in the Carmine cloister was one by Masaccio that also celebrates Carmelite history, although this had a far more recent and local relevance. Depicting the consecration of the Florentine church in 1422 with prominent citizens and church figures in attendance, this work, known familiarly as *The Sagra*, was probably executed in early 1427.

Another early work by Lippi with Carmelite associations survives, a gable-shaped painting of the Virgin and Child with Saint Anne (to whom the order had a special devotion) and two Carmelite saints, Angelo of Licata and Albert of Sicily [FIGURE 67]. That the picture owed part of its existence to Car-

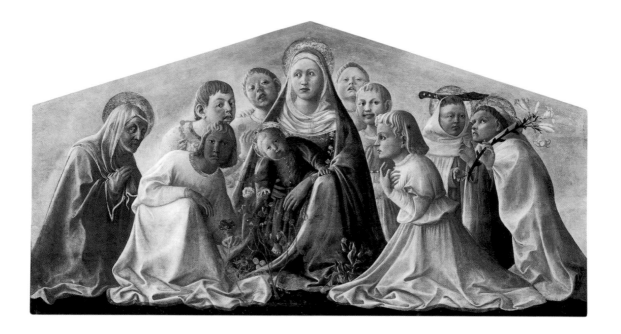

**Figure 67**

Fra Filippo Lippi,
*Madonna and Child with
Saints and Children,*
ca. 1430. Tempera and
gold leaf on panel, 85 ×
168 cm (33½ × 66⅛
in.). Milan, Museo
del Castello Sforzesco
(551). Photo: Alinari/
Art Resource, NY.

melite propaganda can be deduced here by the presence of Saint Albert, the first canonized member of the order (martyred in 1307). According to a decree of 1420, at least one image of that saint was to be present in every Carmelite establishment. Lippi's picture, which has a Florentine provenance, may bear further testimony to such specialized devotion. As recently proposed, it may have been ordered by a local confraternity, the Compagnia di Sant'Alberto, which owned an oratory attached to Santa Maria del Carmine in Florence.[201] Further evidence for this supposition are the garrulous urchins surrounding the Virgin and Child. On closer inspection, they turn out to be not angels but children, for whom the confraternity had a special mission.[202]

In Masaccio's day other, larger Carmelite commissions proliferated, often with multiple narrative scenes chosen for their didactic intent. In the case of the Brancacci Chapel frescoes in Santa Maria del Carmine, we have already seen how the particular narratives painted by Masaccio and Masolino expressed Carmelite views on the role of the Church in modern society. Their sponsorship of the cycle, at least in a thematic way, is implied by the presence of several unidentified Carmelites in two of the scenes. Thus, in Masolino's *Saint Peter Preaching* [FIGURE 68] such figures seemingly comment on the scene, observers from a different place and time. Four such figures also appear in Masaccio's awe-inspiring *Chairing of Saint Peter* [FIGURE 28]. One kneeling friar joins the enthroned Prince of the Apostles in prayer while adoring him in the manner of

a contemporary donor portrait. According to Carmelite legend, members of the order were present at the institution of Peter's appointed role as head of the Catholic Church. Here, the friars and the venerated saint, seen in conjunction, symbolize Carmelite advocacy of the Church and its earthly mission.

Carmelite friars also appear ahistorically in the predella [FIGURE 69] of a contemporary altarpiece by Sassetta, who, as the most progressive Sienese painter of his day, found inspiration in the art of Masaccio. Fundraising for the painting, which was sponsored by the Arte della Lana, or Sienese woolmakers' guild, began in July 1423. By June 6, 1425, the so-called Arte della Lana Altarpiece was complete; on that date it is mentioned in a sermon by Saint Bernardino of Siena.[203] Now dispersed, it consisted of a central image of the Holy Sacrament (now lost) with flanking depictions of Saints Thomas Aquinas and Anthony Abbot and seven predella panels.

The original destination of Sassetta's painting, sometimes said to be San Niccolò del Carmine, has now been shown to be the palazzo of the woolmakers' guild,

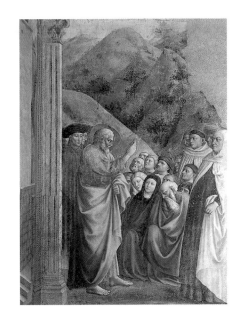

**Figure 68**
Masolino, *Saint Peter Preaching*, ca. 1425. Fresco, 247 × 168 cm (97¼ × 66⅛ in.). Florence, Santa Maria del Carmine, Brancacci Chapel. Photo: © Scala/ Art Resource, NY.

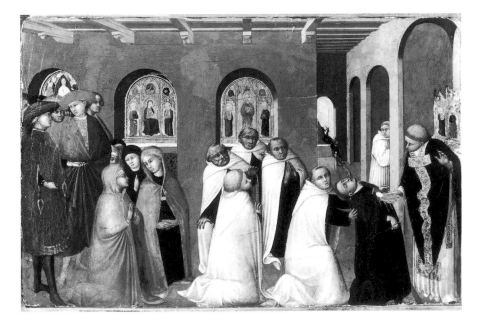

**Figure 69**
Sassetta (Italian, ca. 1400–1450), *A Miracle of the Sacrament*, ca. 1424. Tempera and gold leaf on panel, 24.1 × 38.2 cm (9½ × 15 in.). Barnard Castle, Durham, United Kingdom, Bowes Museum, Founder's Bequest (52).

where it was kept in a cupboard facing the piazza in front of the Carmelite church.[204] In one of Sassetta's six surviving predella panels [FIGURE 69], Carmelites are placed prominently at the center, while presumably officials of the woolmakers' guild look serenely on. In this context, as part of an altarpiece dedicated to the Corpus Domini, or Holy Eucharist, both groups show a special concern with an otherwise unspecified event in which a sacrilegious communicant has just been exorcized.

A lost inscription, beginning with the exhortation "O Fathers" and denouncing "old errors," has been convincingly linked with the important church council of Siena that took place during these very years.[205] The suppression of heresy was one of the council's paramount goals and, by including Carmelite representatives in Sassetta's predella, the order thus affirmed its crucial role in combating a very present threat to Catholic orthodoxy. A similar partisanship informs, as we have seen, a reading of Masaccio's frescoes in the Brancacci Chapel.

Two other *pale* can be called Carmelite commissions by dint of their actual or presumed original destination and by the inclusion of a Carmelite notable. That by Andrea da Firenze (act. 1346–d. 1379) dates from the early 1360s. Now in the sacristy of Santa Maria del Carmine in Florence, it apparently was painted for the no longer extant chapel of Saint Nicholas of Bari.[206] The sole Carmelite feature here is the figure of Elijah, which is loosely based on the figure of the prophet Elisha in Lorenzetti's altarpiece of 1329.[207] Such conservatism would indicate that by Andrea's time Carmelite imagery had attained a certain orthodoxy.

The second altarpiece, by the Florentine painter Ventura di Moro [FIGURE 70], was probably painted for the Observant (or strict) Carmelite house at Le Selve, near Signa west of Florence. The saint at the far left is clearly Albert of Sicily, who also figures in Lippi's painted gable [FIGURE 67]. In 1420, to commemorate its first saint, the order issued an edict to promulgate such images of him: perhaps for that reason this same date appears on the painting's frame.[208] Nevertheless, 1420 may also be deduced on stylistic grounds as the year the painting was made.

The final crowning glory for the Carmine church in Florence, and the last of the public Carmelite images figuring in this discussion, was its high altarpiece, which was painted by Domenico di Bartolo (act. 1420–44/45) of Siena. However, whether Carmelite iconography informed that work is unknown, since the only reference to it is a passing remark in Vasari's *Lives*.[209] Recently a fragmentary *Madonna and Child* in the University Art Museum, Princeton, has been identified with the Carmine altarpiece and dated on stylistic grounds to the mid- to late 1430s.[210] But, with so little of Domenico's image remaining, there is no evidence of a specifically Carmelite iconography.

**Figure 70**

Ventura di Moro (Italian, ca. 1395–1486), *The Madonna and Child with Four Saints*, 1420 [?]. Tempera and gold leaf on panel, 218.4 × 251.4 cm (86 × 99 in.). New Haven, Yale University Art Gallery, University Purchase from James Jackson Jarves (1871.22).

For almost a hundred years, then, the Carmelites in Tuscany had fashioned a painted imagery, of which some examples were more specifically Carmelite than others. Lorenzetti's altarpiece of 1329 chronicled key events in the order's history and, as in several of the Brancacci Chapel frescoes and one by Fra Filippo Lippi, bespoke its ancient roots. On the other hand, the program of Masaccio's and Masolino's cycle and the predella of Sassetta's roughly contemporary Arte della Lana Altarpiece commented on recent events. Thus, at a time when the Church faced the challenge of heresy and various schismatic church councils, these images expressed Carmelite solidarity with the papal cause. In addition, paintings by Ventura di Moro and Lippi developed the growing cult of Carmelite saints.

In Tuscany, small panel paintings intended for private devotion enriched the life of Carmelite friars in a more personal way. Two such works, dating from about 1425 to 1430, must have served as devotional aids placed in friars' cells. The first is *The Madonna and Child with Saints and Angels* by Fra Filippo Lippi [FIGURE 54], which relates to his two, slightly earlier works, discussed

83

**Figure 71**

Battista di Gerio (Italian, documented 1414–1418), *The Madonna and Child between Saints Albert of Sicily and Paul*, ca. 1425. Tempera and gold leaf on panel, 56 × 40.8 cm (22 × 16 in.). London, private collection. Photo: Sotheby's, London.

above, and reflects in miniature form the great innovations of Masaccio's Pisa Altarpiece. In the place of honor to the Virgin's right appears the premier Carmelite saint at the time, Albert of Sicily, while standing below is Saint Michael. Although the picture's provenance is unknown, its first owner may have been Angelo Mazzinghi, the prior of the Observant Carmelite community at Le Selve, whose patron saint was the Archangel Michael.[211]

The other private devotional panel, *The Madonna and Child between Saints Albert of Sicily and Paul* by Battista di Gerio [FIGURE 71], has been dated to about 1425.[212] This rather obscure artist spent his early years in Pisa. After 1418, though, he settled in Lucca, where employment appears to have been more plentiful. There he probably produced the present panel for a member of the local Carmelite convent.

No doubt the original number of such small devotional aids was much greater, but, as with portraits from this distant age, such personal items must

have been especially prone to wear, loss, and destruction. For our purposes, suffice it to say that the two panels by Lippi and Battista di Gerio owe their existence to Carmelite devotion. So do the altarpieces and frescoes by Pietro Lorenzetti, Andrea da Firenze, Ventura di Moro, Sassetta, Masaccio, Fra Filippo Lippi, and Domenico di Bartolo discussed above. All of these works of art added luster and prestige to the order's churches and monasteries in Tuscany. By 1430, artistically speaking, the Carmelites there had clearly arrived.

The timing of several of the above-mentioned artistic commissions has relevance too; several works reflect the growing cult of Saint Albert. With this in mind, let us look again at Masaccio's Pisa Altarpiece. The content of the central panel, as we have seen, and to an extent the selection of saints, must have been supervised by a prominent Carmelite theologian, namely Fra Antonio di Matteo. Could the altarpiece's commission have been prompted by a particular moment in the order's history? This hypothesis is likely because 1426 was the two hundredth anniversary of Pope Honorius III's confirmation of the order. This was a major event in Carmelite history, consisting of papal approval of the original founding charter, the Carmelite garb, and their particular form of Marian devotion, which commemorated the vision of the Virgin Mary on Mount Carmel.

To commemorate the *one* hundredth anniversary of the confirmation of the Carmelite rule, just possibly, Pietro Lorenzetti may have received the original commission to paint the high altarpiece for San Niccolò del Carmine [FIGURE 65], which became the leading Carmelite work of art in Siena. Only the year of completion for this polyptych is known, 1329, but as it was a particularly large and important complex, the project could have taken the artist up to three years to complete. Alternatively, delays may have occurred due to funding or other reasons, with the result that work on the altarpiece did not commence until after 1326.

Although Masaccio began the Pisa Altarpiece on February 19, 1426, the signed contract, as with the Lorenzetti polyptych, is lost.[213] Presumably it discussed some of the motivating factors behind the commission and stipulated a deadline. Apparently there were delays. As a result, on October 15 Ser Giuliano wrote that Masaccio "had promised me not to do any other work before completing" the altarpiece.[214] As it turned out, Masaccio finished the painting by December 26, when final payment was made. Still, Ser Giuliano's insistence that his altarpiece be completed by the year's end may not have been motivated simply by personal considerations, such as his well-documented penchant for meticulousness. Rather, there may have been a demand on the part of the Carmelites, too, to have Masaccio's painting completed by 1426, given the important two hundredth anniversary of the confirmation of the order's rule.

# THE LATER HISTORY
## OF THE ALTARPIECE

Masaccio's altarpiece [FOLDOUT] remained in situ for about a century and a half. Then, in 1568, the very year that Vasari issued the second edition of his *Lives*, the church of Santa Maria del Carmine underwent reconstruction that lasted until 1574.[215] Part of this renovation involved lining the nave with a series of new side altars, which were provided with altarpieces by contemporary Tuscan painters, most of which remain in the church to this day. New conditions in the Counter-Reformation Catholic Church necessitated these changes, conditions soon codified by the Council of Trent. Similar architectural renovations took place at this time in Florence. There the degree of documentation is much greater, enabling us to deduce something of concomitant developments in Pisa. In Florence the two largest churches, Santa Croce and Santa Maria Novella, had their side altars replaced and new altarpieces were provided. Yet the most dramatic change was the removal of each church's tramezzo, which, in the spirit of the Council of Trent, was deemed undesirable since it obscured the Host and limited lay participation in daily worship. A comparable renovation of Santa Maria del Carmine in Florence began in 1568.[216] By 1600 all rood screens in Florentine churches had been demolished.

Almost certainly, the same operation formed part of the structural and liturgical changes that took place at the Carmelite church in Pisa between 1568 and 1574. If so, Ser Giuliano's chapel, attached as it was to the tramezzo, would have been destroyed. With new, updated altarpieces then in place, Masaccio's painting must have been removed, either to a new chapel in the Carmine or to the sacristy.

A reconstructed church—taller, perhaps longer, but in all likelihood retaining its original width—was eventually consecrated in 1612.[217] By about this time, however, sections of Masaccio's altarpiece had already been dispersed. One of its smaller parts, the *Saint Paul* [FIGURE 8], had entered the collec-

tion of Dean Francesco Berzighelli. By 1640, he, in turn, had presented the panel to a local antiquary and collector, Paolo Tronci (1585–1648), who, two years earlier, had been appointed the church's overseer.[218] (Until recently, the panel was said to have formed part of the 1796 donation of Canon Sebastiano Zucchetti to the Opera del Duomo, whose collections were to form the nucleus of the future museum.) According to Tronci,[219] his *Saint Paul* was by Masaccio and had come from the Carmine.

Here at last is a clue suggestive of the later fate of Masaccio's altarpiece. In all likelihood, Berzighelli's possession of the *Saint Paul* was due to his family connections with Santa Maria del Carmine. After all, an earlier Francesco Berzighelli and his brother Giovanni, both sons of the recently ennobled Bartolomeo Berzighelli, had established one of the new altars in the church, namely the second one on the right upon entering the building [FIGURES 58, visible at the right, 59].[220] This location was dedicated in 1579 to the Assumption of the Virgin, the subject of a roughly contemporary altarpiece still in situ by Santi di Tito (1536–1602).[221]

Had the Berzighellis bought or inherited Ser Giuliano's chapel before the tramezzo was dismantled, and with it the famous Pisa Altarpiece? We cannot say; virtually nothing is known about the later history of Ser Giuliano's family. In 1456 Ser Giuliano died childless. His three main beneficiaries were his wife, Pisa cathedral, and the church of Santa Maria del Carmine. It is thus altogether possible that at that point Masaccio's altarpiece became the property of the Carmelites, and that they in turn sold it to the Berzighellis.

Sometime before Tronci received the *Saint Paul*, Masaccio's altarpiece had been broken up, in the "usual and barbarous Pisan custom" that was to be the fate of so many local altarpieces at the end of the eighteenth century.[222] A main incentive for this later practice was the growing demand for "primitives," one that figures such as the Pisan printmaker and collector Carlo Lasinio (1759–1838) did much to satisfy and promote. Yet even at this fertile moment in the history of collecting, no records can be found for the remaining parts of Masaccio's altarpiece.

Not until 1846 do we find the next published notice of two of the surviving panels. This occurs in Federico Fantozzi's guide to Florence, in which the writer describes the large picture collection of the famous statesman, historian, and educator marchese Gino Capponi (1792–1876), then housed in his palazzo on the present-day Via Gino Capponi.[223] There, in the "Quarta Stanza" of the *piano nobile* could be seen an "Epifania" and a "Martirio dei SS. Pietro e Paolo [sic]," both ascribed to the "style of Masaccio" [FIGURES 30, 42]. Whether Fantozzi or Capponi was aware of the panels' origin or of Vasari's enthusiastic reference to

*The Adoration of the Magi* predella is not a matter of record, and so far, we have no knowledge of how Capponi acquired the two paintings.

Of the many pictures Fantozzi itemized in Capponi's collection, only a handful predate the sixteenth century. Of these the high points were the two predella panels of Masaccio and Botticelli's *Last Communion of Saint Jerome* (Metropolitan Museum of Art, New York). Yet in a catalogue accompanying the 1849 sale of the Thomas Blayds collection in distant London, no less than four other early Italian panel paintings appeared with a provenance from the "Caponi [sic] Gallery at Florence."[224]

It is the provenance of these additional Capponi paintings that is of interest for our discussion. Did any of them, like the Masaccio predella panels, also hail from the region around Pisa? In fact, one of Blayds's pictures, an altarpiece by Taddeo di Bartolo, came originally from the village of Collegarli, near San Miniato al Tedesco, which lies about midway between Pisa and Florence.[225] In addition, the marchese Capponi owned a factory near the town of Pontedera, which is situated not far from Pisa.[226] These connections to western Tuscany suggest that Capponi may have acquired the predella to Masaccio's Pisa Altarpiece in the same region. Or perhaps he inherited them. His great-great-great grandfather Giuliano Capponi (1569–1649) had been grand prior of a monastery in Pisa in 1644.[227] Had he, like his contemporary Paolo Tronci, received another part of the Pisa Altarpiece from a Berzighelli family member? If this uninterrupted provenance could be proved, it may explain why such a key monument in the history of Italian Renaissance painting as Masaccio's predella was totally unknown to the world at large until Fantozzi's publication.[228]

After Capponi's death in 1876, several of his pictures, including the Botticelli and the two predella panels by Masaccio, were eventually put up for sale. In fact, three years later, the Botticelli and Masaccio's predella panel depicting the martyrdom of Saints Peter and John the Baptist, as well as three other works, including a portrait of a man ascribed to Franciabigio, were appraised by no less a personality than the Italian connoisseur and patriot Giovanni Morelli (1819–1891). In a recently published letter from Morelli, dated July 24, 1879, and addressed to the marchese Niccolò Antinori (1817–1882) in Florence,[229] the writer sent congratulations to "la nobile Signora Giulia Ridolfi" (a granddaughter [née Farinola] of Capponi, who in 1851 had married Luigi Ridolfi)[230] and then blithely added "and tell them that in any case her pennies would be worthily spent, if she was able to have" the above-mentioned Botticelli, "the two predellas, with martyrdom of saints (?) which I consider works of Masolino da Panicale" (appraised at three thousand lire), two other paintings, and "the portrait of a man, marked with the cipher of Franciabigio . . ."[231]

There can be no doubt that the Botticelli under discussion was the one formerly belonging to the marchese Capponi and now in the Metropolitan Museum. However, the identification of "the two predellas, with martyrdoms of saints (?)," ascribed by Morelli to Masolino, with Masaccio's *Martyrdom of Saints Peter and John the Baptist* appears problematic. To begin with, there is the matter of Morelli's vague recitation of the picture's subject matter, but this can be put down to the relative unimportance of the latter when appraising paintings and to the informal nature of the medium, namely personal correspondence. But what about the attribution to Masolino? Here it should be remembered that, several years previously, Capponi's painting had been listed in Fantozzi's guide as simply "style of Masaccio," and this attribution was repeated by Morelli himself in an otherwise unknown catalogue of the marchese's collection cited years later by Wilhelm von Bode (1845–1929).[232] Moreover, the conception of Masaccio's style until at least the fourth quarter of the nineteenth century was very much in flux. As with Giotto, a wild assortment of paintings passed under his name, and even his bona fide sections of the Brancacci Chapel were, as we have seen, considered the work of Masolino.[233] Because there is no evidence that Morelli thought much differently about the matter, we can safely maintain the present identification.

That Morelli was indeed referring to several of the late Gino Capponi's pictures can be proven in other ways. First there is his mention of the portrait "marked with the cipher of Franciabigio." That painting can be reasonably identified with the Franciabigio portrait described by Fantozzi in Capponi's collection as inscribed "A.D.M.D.XVII-DX.S" and known to have been acquired later by the Liechtenstein family in Vaduz, its present owners. A second consideration is that Morelli was a profound admirer of Capponi who, like him, had dedicated much of his life to the cause of Italian liberty. Almost seventy letters between the two figures attest to their friendship.[234] Third, Morelli actually identified Capponi as the collector in another letter, published for the first time below.

As it happened, Giulia Ridolfi never acquired the Masaccio predella panels from her grandfather Capponi's estate. In March 1880 von Bode, who had come to Florence for the San Donato sale of the fabled Demidoff collection, bought "both costly predella pieces" from Capponi's heirs for roughly 7,500 German marks.[235] For some time this giant of the art world had brilliantly and aggressively been acquiring works of art in Florence for the Berlin museums, of which he was director.[236] Perhaps von Bode even learned of the Masaccio predella panels from Fantozzi's guide of 1846 and added it to his acquisition desiderata, much as he and previous directors of the German museums seem to have used the richly detailed accounts of Italian paintings in British collections

written by Gustav Friedrich Waagen, another Berlin gallery director, as a sort of shopping list for future museum purchases.[237] In June 1888, von Bode published his two purchases in the *Gazette des Beaux-Arts*, identifying them as part of the predella of the Pisa Altarpiece.[238]

Morelli, in the meantime, was furious that such masterpieces (as he subsequently learned) had just left the country. As he wrote to Antinori in an unpublished, follow-up letter of August 8, 1879:

> As for the question you had for me regarding certain paintings in the Galleria Capponi, it's better that I respond to you verbally. It certainly irritates me, thinking of the humiliation that one feels has accrued to the memory of the excellent Gino [Capponi], letting such precious works of art such as those four or five small paintings—as indicated by me in my last letter—leave the country. They certainly don't have any sense of dignity any more in Italy, either as individuals or collectively.[239]

Still, Morelli may have been able to prevent the export of Botticelli's *Last Communion of Saint Jerome*, at least temporarily. In 1909 it was sold via an art agent to Benjamin Altman, who later bequeathed it to the Metropolitan Museum of Art.

At that time the leading specialist on the art of Masaccio was August Schmarsow (1853–1936), a professor of art history at Breslau (the present-day Wroclaw in Poland), whose first volume of a five-part monograph on the artist appeared in 1895.[240] In 1896 Schmarsow acknowledged in print the existence of other components of Masaccio's Pisa Altarpiece: the four pilaster panels depicting two Carmelite saints, Saint Jerome, and Saint Augustine [FIGURES 44–47].[241] These had been lent by the English dealer and collector Charles Butler (1815–1911) in 1893–1894 to an exhibition at the New Gallery, London, where they were attributed to Masaccio.[242] Their earlier history is unknown. Butler offered them to the National Gallery, London, which at the time had no works by the master, but they were passed over.[243] Von Bode then acquired all four in 1905 from an anonymous London collection.[244] Prior to that, they had been proposed to the Metropolitan Museum by the art historian and dealer Robert Langton Douglas (1864–1951), who dealt frequently with von Bode.[245] Perhaps he and not Butler, as is frequently said, was the source for these four panels.

Unbeknown to art historians throughout this period, the central panel of Masaccio's altarpiece, *The Madonna and Child with Four Angels* [FIGURE 35], had been in England since at least the mid-nineteenth century. It then figured in the estate sale of Italian pictures belonging to Samuel Woodburn (1780–1853), which took place at Christie's on June 9 and 11, 1860.[246] According to a label still on the back of the panel, which reads *MISS WOODBURN / MARCH 13, 1855* and is

numbered 70, the painting was apparently inherited by Woodburn's sister, Mary Frances Woodburn; in the 1860 sale it was bought by a certain "Clarke."[247]

Samuel Woodburn was the greatest dealer of nineteenth-century Britain, especially for old master drawings and the so-called Italian primitives. In the latter category the quality of his holdings was outstanding, even though certain attributions could be either wrong or simply overly optimistic. (The "Masaccios" in the 1860 Christie's sale catalogue, for example, are not by his hand, while that master's *Madonna and Child with Four Angels* was misattributed to Gentile da Fabriano.) Yet, up until now, little has been known of this fascinating figure and his mode of operations. Thanks to the pioneering research of Nicholas Penny, we now learn that the Masaccio was but one of a host of early Italian paintings that Woodburn and his brothers had imported from Florence en bloc by 1847. In an undated notebook cited by Woodburn in a letter of that year, the dealer enumerated over eighty Italian paintings.[248] These he was happy to offer the National Gallery for the huge sum of £12,600. The gallery trustees, however, demurred. Alienated partly by the dealer's increasingly erratic behavior and by a lingering prejudice against early (as opposed to High) Renaissance art, they turned Woodburn down. As a result, by 1850 what was described in the press as a "mass of rubbish of the Florentine school" remained in Woodburn's hands.[249]

As Woodburn had purchased *The Madonna and Child with Four Angels* in Florence, it is tempting to identify this section of the Pisa Altarpiece with "a beautiful painting by the famous Masaccio . . . *stupendissimo*" that was offered on the Florentine art market for twenty *zecchini* on April 22, 1800. Yet the information given by the art agent at that time—an otherwise unknown figure, Gaetano Cristoforo Galeazzi—is frustratingly terse. All that we know of this painting is that it contained six figures. This description could apply to either the London panel alone or, not counting the angels, the London picture *and* the attendant figures of Saints Julian, Nicholas, Peter, and John the Baptist, the side panels of Masaccio's *pala* that have never been found.[250]

Whoever the "Clarke" was who bought Masaccio's *Madonna and Child with Four Angels* at the Woodburn sale did not own it for long. In 1864 it appeared in the collection of Canon Frederick Heathcote Sutton (1833–1888), who in 1873 became the energetic rector of Saint Helen's Church in the village of Brant Broughton near Lincoln, Lincolnshire.[251] At his death the Masaccio, as well as Sutton's clerical post, were inherited by his nephew Arthur Frederick Sutton (1852–1925).[252] The painting was still attributed to Gentile da Fabriano when Bernard Berenson (1865–1959) saw it in that collection sometime during a visit to Britain in November and December 1906.[253] In a brief announcement the following September, Berenson, the greatest living connoisseur of early Italian

painting, declared the discovery of a Masaccio, which he tentatively equated with the central panel of the long-lost Pisa Altarpiece.[254] He confirmed his hunch in the May 1908 issue of *Rassegna d'arte*.[255] Eight years later the Reverend Sutton sold *The Madonna and Child with Four Angels* to the National Gallery.

As we have seen, Schmarsow was the first to publish the four pilaster panels of saints that later entered the Kaiser-Friedrich-Museum. At the same time he also introduced the *Saint Andrew* panel [FIGURE 1], then in the collection of Count Karol Lanckoronski (1848–1933) [FIGURE 72] in Vienna.

A short guide to the neo-Baroque Palais Lanckoronski, privately printed in 1903, reveals remarkable Italian paintings.[256] In rooms such as the contiguous "Italienischen Saal," "Kapelle," and "Kleines Italienisches Cabinet" (where the Masaccio hung), one could view such world-class pictures as Uccello's *Saint George and the Dragon*, Simone Martini's *Angel*, and Dosso Dossi's stunning *Jupiter, Mercury, and Iris*, which was recently returned to the family and now forms part of the Lanckoronski donation to Poland.[257] The sheer quality of the Lanckoronski palace's holdings, their volume and very wide range, invited comparison with the two other leading collections in Vienna, those of the Liechtenstein and Harrach families.

Ten extremely detailed watercolors by Rudolf von Alt (1812–1905) document the interior of the Palais Lanckoronski. Commissioned from the artist in 1881, these actually predate the acquisition of Masaccio's *Saint Andrew*.[258] Another watercolor, though, by Ludwig Hans Fischer, provides a tantalizing view of the "Kleines Italienisches Cabinet" [FIGURE 73].[259] Undated, it presumably records the same layout as that recounted in the 1903 guide. In that case, Masaccio's *Saint Andrew* would have hung just to the right of the door, an area frustratingly cropped in Fischer's composition. As partial compensation, we can point to Uccello's *Saint George and the Dragon* (now in London) over the sofa at left.

In the first half of the twentieth century much of the Lanckoronski collection remained intact, despite some

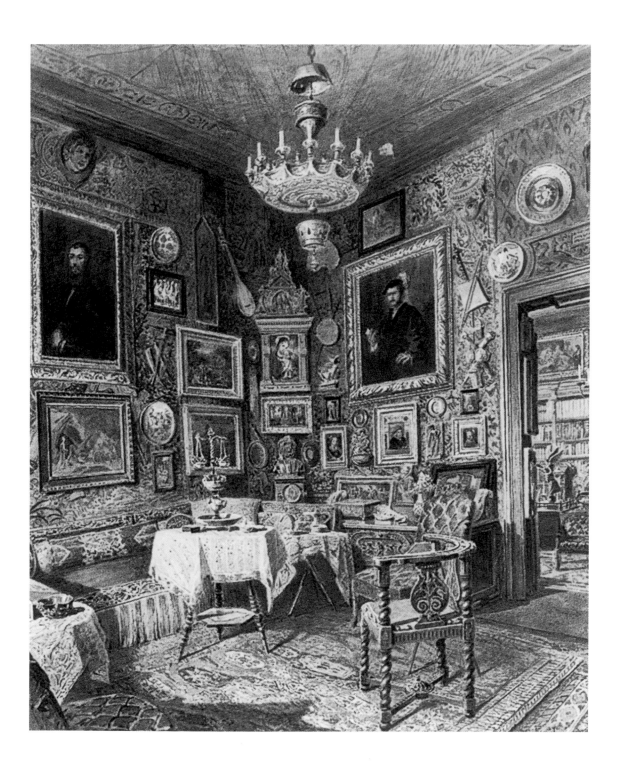

**Figure 74**
Arnold Böcklin (Swiss, 1827–1901), *Portrait of Adolf Bayersdorfer*, 1875. Oil on board, 39 × 30 cm (15⅜ × 11¹³⁄₁₆ in.). Basel, Kunstmuseum (1460). Photo: Oeffentliche Kunstsammlung Basel, Martin Bühler.

sales, sequestration by the Nazis after the annexation of Austria, and several subsequent major losses. Then in, 1994, following the fall of the Soviet puppet regime in Poland, the daughter of Count Karol, Professor Karolina Maria Lanckoronska, presented the collection to the Polish nation. It is now housed in the Royal Palace, Warsaw, and in Wawel Castle, Kraków.

The full story of how Count Karol Lanckoronski assembled his prize collection of Italian paintings and sculpture remains to be written. According to one source, this venture was begun around 1880 and later developed with advice from Berenson.[260] The two figures clearly knew each other, as is attested by Lanckoronski's daughter and a passage in one of Berenson's publications.[261] In addition, there is said to have been correspondence from Berenson conserved in the Palais Lanckoronski, but this was destroyed with most of the palace's contents during World War II.[262] On the other hand, no correspondence from Lanckoronski exists in the Berenson Archive at Villa I Tatti, near Florence. This is all the more confusing as old photographs of many Lanckoronski pictures appear in the Fototeca Berenson, and such works are mentioned in Berenson's famous "Lists" of Italian Renaissance paintings.

According to Professor Johannes Wilde (1891–1970), Masaccio's *Saint Andrew* was a gift to Count Lanckoronski at some undisclosed time from Adolph Bayersdorfer (1842–1901) [FIGURE 74], a remarkable connoisseur, art agent, and curator.[263] Bayersdorfer seems to have owned the picture as late as 1892 during his tenure as curator of the Alte Pinakothek, Munich.[264] This was just a few years before Lanckoronski built his palace in Vienna and about contemporary with the acquisition of some of his most important Italian paintings—the Domenichino frescoes from the Villa Aldobrandini (now in the National Gallery, London), purchased in 1892, and the Uccello *Saint George and the Dragon*, bought some five or six years later.[265] Bayersdorfer had known Lanckoronski since at least his early years in Florence, where he lived from 1874 to 1879, earning a reputation (as one contemporary wrote) as "simply the

foremost connoisseur of paintings in all Europe."[266] In time Lanckoronski would avail himself of Bayersdorfer's expertise, as when in early 1893 he asked his friend to view several paintings about to be auctioned in Milan.[267] By this point Bayersdorfer must have realized that the count was fast becoming a formidable collector of early Italian paintings. With this in mind, he may have felt that the time was right—sometime after 1892—to present his *Saint Andrew* by Masaccio to Lanckoronski.[268]

The picture remained in the Lanckoronski collection for roughly eighty more years. After the death of Count Karol in 1933, his children decided to close the Palais Lanckoronski and made plans to transfer the family pictures to their estates in what was then Lwow, Poland (the present-day L'viv, Ukraine). But just as an export license was finally granted in 1938, the German annexation of Austria took place. The Nazi regime confiscated the collection (consisting of 1,695 objects) and sent it for storage to Schloss Steiersberg near Wiener-Neustadt.[269] Meanwhile, the Palais Lanckoronski was partially destroyed during bombing raids over Vienna in the spring of 1945. When the pictures from Schloss Steiersberg were returned to Count Lanckoronski's children following World War II, the paintings were stored at a family hunting lodge at Hohenems, in the Vorarlberg Mountains. As the threat of a Communist takeover loomed over Austria, some of the choicest paintings, including the *Saint Andrew*, were transferred to nearby Switzerland, thus allowing them to escape a disastrous fire at Hohenems that destroyed 102 pictures. Then, in 1979, in order to fund the Polish Library in Paris, Countess Karolina Lanckoronska consigned the *Saint Andrew* to Heim Gallery, London, which in turn sold it to the Getty Museum.[270]

A major component of the Pisa Altarpiece was identified by Wilhelm E. Suida (1877–1959), who in 1906 published *The Crucifixion* [FIGURE 40] as the work of Masaccio.[271] This panel had been acquired by the Museo Nazionale di Capodimonte, Naples, in 1901 on the advice of Adolfo Venturi (1856–1941), who at the time had proposed the attribution in a local paper.[272] (He returned to the subject ten years later in a volume of his monumental *Storia dell'arte italiana*.)[273] Nothing is known of the painting's immediate provenance other than its vendor in 1901, a certain Gaetano De Simone, who had proposed the painting three years before.[274]

By no means the last piece of the puzzle was added in 1908 by Detlev, Freiherr von Hadeln (1878–1935).[275] This was the remaining part of the predella, the panel depicting scenes from the legend of Saints Julian and Nicholas, and which, he stated, was then on the art market in Florence [FIGURE 43]. The quality of the execution and even the design led von Hadeln to deny Masaccio's authorship and assign it instead to the master's assistant during his stay in Pisa, Andrea di Giusto.

In the very year of von Hadeln's article, the painting was acquired by the Kaiser-Friedrich-Museum, Berlin, as the gift of an anonymous donor. This, it turns out, was none other than Wilhelm von Bode, who, aided by one of his assistant directors, Dr. Frida Schottmüller (1872–1936), then in Florence, had obtained the work with considerable stealth. Von Bode had probably learned of the predella from one of his key contacts in Florence, Luigi Grassi (1858–1937), who may have been in touch with its owner, the German expatriate painter Carl Strauss (born 1873). As the Kaiser-Friedrich-Museum already owned the other sections of Masaccio's predella, it was essential, at this point in the museum's negotiations, not to evince too much interest in order to acquire the work for a reasonable sum. As part of their plan, Schottmüller therefore purchased the panel herself. She then (according to a letter to von Bode dated May 19, 1908) concealed the predella in her baggage—it "was unfortunately too long," she said, to place in her handheld suitcase—and took it with her directly to von Bode in Berlin.[276]

In all likelihood, we may never know how the Pisa Altarpiece originally looked. Still, there remains the tantalizing possibility that other missing parts could yet come to light. This would mean the rediscovery of the panels depicting Saints Julian, Nicholas, Peter, and John the Baptist from the main picture field; at least two more panels of three-quarter-length saints from the level above (the companions to the Pisa *Saint Paul* and the Getty Museum's *Saint Andrew*); two panels from the altarpiece's right pilaster representing Saints Gregory and Ambrose; and (as proposed here) two panels in the uppermost register flanking the *Crucifixion* now in Naples. As we have seen, the ways that the extant portions of the altarpiece have surfaced over the years have been various indeed, and their early histories to this day are still mostly mysterious. Should more elements reappear, one can imagine that their course will have been different still. In the case of a great altarpiece by one of the truly pioneering figures in the history of art, one that saw only one and a half centuries of service, any new additions to Masaccio's tiny oeuvre would be historic.

# NOTES

1. Eve Borsook, "A Note on Masaccio in Pisa," *Burlington Magazine* 103 (May 1961), p. 212.

2. On this statue, see Horst W. Janson, *The Sculpture of Donatello* (Princeton, 1979), pp. 45–56; John Pope-Hennessy, *Donatello, Sculptor* (New York, 1993), pp. 48–55, and Artur Rosenauer, *Donatello* (Milan, 1993), pp. 59–60, no. 8.

3. Paul Joannides, "Masaccio, Masolino and Minor Sculpture," *Paragone* 451 (September 1987), p. 10; and idem, *Masaccio and Masolino: A Complete Catalogue* (London, 1993), p. 153.

4. Luciano Berti, "Masaccio 1422," *Commentari* 12 (June 1961), p. 93.

5. For this phenomenon, see the stimulating remarks of Richard A. Goldthwaite, *Wealth and the Demand for Art in Italy, 1300–1600* (Baltimore and London, 1993), pp. 138–148.

6. Condition report, David Bull, Conservation Department, The J. Paul Getty Museum, March 18, 1980.

7. For technical evidence indicating that the *Saint Andrew* and the *Saint Paul* originally had rounded, not Gothic, arches, see Roberto Bellucci et al., "Technical Catalogue," in Carl Brandon Strehlke and Cecilia Frosinini, eds., *The Panel Paintings of Masolino and Masaccio: The Role of Technique* (Milan, 2002), p. 194.

8. For the *Saint Paul*'s dimensions, see Bellucci et al. (note 7), p. 194.

9. Bellucci et al. (note 7), p. 198. For detailed dimensions of the *Saint Andrew*, I am indebted to Yvonne Szafran of the Getty Museum's Paintings Conservation Department (letter to author, February 20, 2001).

10. Pigment analysis from reports on file at the Paintings Conservation Department, J. Paul Getty Museum, by John Twilley, "Analysis and Materials Science for the Preservation of Cultural Property," Riverside, Calif., August 8, 1979; and Ashok Roy, Scientific Department, National Gallery, London, November 30, 1987 (from paint samples brought to London by Joyce Plesters in 1979).

11. Luciano Berti and Rossella Foggi, *Masaccio: Catalogo completo dei dipinti* (Florence, 1989), p. 13.

12. James H. Beck, *Masaccio: The Documents* (Locust Valley, N.Y., 1978), p. 6.

13. Giorgio Vasari, *Le vite de' più eccellenti pittori, scultori ed architettori*, ed. by Gaetano Milanesi, vol. 2 (Florence, 1878), p. 289.

14. See Beck (note 12), pp. 5–7, Document I. Manetti's account remained unpublished until the late nineteenth century.

15. Beck (note 12), pp. 8–9, Document IV.

16. Although dated to ca. 1420 by Miklòs Boskovits ("Mariotto di Cristofano: Un contributo all'ambiente culturale di Masaccio giovane," *Arte illustrata* 2 [January/February 1969], p. 7), the Preci Altarpiece nevertheless seems later than the Cionesque *Madonna and Child with Eight Saints* (Museo di Palazzo Venezia, Rome), which Boskovits also dates to ca. 1420; indeed, it has more in common with Mariotto's only dated picture, a double-sided altarpiece of 1445–47 (Accademia di Belle Arti, Florence).

17. Beck (note 12), p. 8, Document III.

18. See Ugo Procacci, *Masaccio* (Florence, 1980), pp. 10–11, who omits any archival source for this information.

19. Beck (note 12), pp. 11–12, Document VII.

20. Roberto Bellucci and Cecilia Frosinini, "Working Together: Technique and Innovation in Masolino's and Masaccio's Panel Paintings," in Strehlke and Frosinini (note 7), p. 62, n. 14.

21. Beck (note 12), pp. 9–11, Document V, and p. 11, Document VI.

22. Beck (note 12), p. 10.

23. Joannides, *Masaccio and Masolino* (note 3), pp. 426–429, no. 26. In the interest of brevity, references to individual paintings will be confined to catalogue numbers in Joannides's outstanding monograph, where previous bibliography may be found, or to selected later bibliography. In this case, see also Anja-Silvia Göing, *Masaccio? Die Zuschreibung des Triptychons von San Giovenale* (Hildesheim, Zurich, and New York, 1996).

24. On Vanni Castellani as patron, see Ivo Becattini, "Il territorio di San Giovenale ed il trittico di Masaccio," in Caterina Caneva, ed., *Masaccio 1422/1989. Dal trittico di San Giovenale al restauro della Cappella Brancacci: Atti del convegno del 22 aprile 1989* (San Giovanni Valdarno, 1990), pp. 17–26.

25. On the Master of 1419, see entry by Cecilia Frosinini in Federico Zeri, ed., *La pittura in Italia: Il Quattrocento* (Milan, 1986), II, pp. 683–684.

26. On Giovanni, see Curtis H. Shell, "Giovanni dal Ponte and the Problem of Other, Lesser Contemporaries of Masaccio" (unpublished Ph.D. dissertation, Harvard University, 1958).

27. Joannides, *Masaccio and Masolino* (note 3), p. 57, who notes (p. 428) that several of the punchmarks used in the gold tooling of the San Giovenale Triptych can be compared with those in a work by Giovanni dal Ponte. Punchtools were often passed from master to pupil and, because of this practice, the presence of individual punchmarks can sometimes aid in confirming attributions.

28. Berti (note 4), p. 93, n. 15.

29. Joannides, "Masaccio, Masolino and Minor Sculpture" (note 3), pp. 5–6.

30. Bernard Berenson, *The Florentine Painters of the Renaissance*, 2d ed., rev. (New York, 1896), p. 27.

31. Frederick Hartt, "Art and Freedom in Quattrocento Florence," in Lucy Freeman Sadler, ed., *Essays in Memory of Karl Lehmann* (New York, 1964), pp. 114–131.

32. Beck (note 12), pp. 24–29, Documents XXVII–XXVIII.

33. For the following documentation, see Joannides, *Masaccio and Masolino* (note 3), pp. 25–28, and Perri Lee Roberts, *Masolino da Panicale* (Oxford, 1993), pp. 5–9. For an excellent account of the two painters' (undocumented) partnership, see idem, "Collaboration in Early Renaissance Art: The Case of Masaccio and Masolino" in Diane Cole Ahl, ed., *The Cambridge Companion to Masaccio* (Cambridge, 2002), pp. 98–104.

34. Vasari (note 13), p. 264.

35. Joannides, *Masaccio and Masolino* (note 3), pp. 350–355, no. 13.

36. Leon Battista Alberti, *On Painting*, trans. and ed. by John R. Spencer (New Haven and London, 1971), p. 56. Alberti's text, *Della pittura*, appeared in 1436, while a version in Latin had been issued one year earlier. Proof that Masaccio's predella was originally part of the Carnesecchi Altar-

piece is that its wood grain matches that in Masolino's *Saint Julian* (Bellucci et al. [note 7], p. 154).

37. Joannides, *Masaccio and Masolino* (note 3), pp. 369–372, no. 15.

38. The modeling of the Virgin's draperies in the San Giovenale Triptych has been lost due to the fugitive properties of the lapis lazuli pigment used in this area.

39. According to Luciano Berti, *Masaccio* (University Park, Pa., and London, 1967), p. 62, the inspiration for this passage came from the central panel of Gentile da Fabriano's Quaratesi Altarpiece, completed in May 1425, which thus becomes a possible *terminus post quem* for Masaccio's figure.

40. Richard Fremantle, "Masaccio e l'antico," *Critica d'arte* N.S. 16 (May 1969), p. 41.

41. Joannides, *Masaccio and Masolino* (note 3), pp. 440–441, no. 30.

42. See John Pope-Hennessy, "Connoisseurship," in *The Study and Criticism of Italian Sculpture* (New York, 1980), pp. 25–27. Here it should be noted that the attribution to Masaccio has again been called into question, on the basis of its underdrawing, by Carl Brandon Strehlke, "The Case for Studying Masolino's and Masaccio's Panel Paintings in the Laboratory," in Bellucci et al. (note 7), p. 23.

43. Conservation by David Bull of New York, 2001–2002.

44. Joannides, *Masaccio and Masolino* (note 3), p. 440.

45. The same suggestion was made independently by Roberto Bellucci and Cecilia Frosinini, "Masaccio: Technique in Context," in Ahl (note 33), p. 244, n. 30; for the 1426 document, see Beck (note 12), pp. 20–21, Document XX.

46. Beck (note 12), pp. 15–16, Document XII.

47. Joannides, *Masaccio and Masolino* (note 3), pp. 313–349, no. 12.

48. Vasari (note 13), pp. 264–265 (life of Masolino), 289, 297 (life of Masaccio).

49. This point is emphasized in John Pope-Hennessy, "Unveiling Masaccio's Radical Masterpiece in Florence," *Architectural Digest* 47 (March 1990), p. 38. Recently, Diane Cole Ahl, "Masaccio in the Brancacci Chapel," in Ahl (note 33), pp. 144–145, has suggested that Brancacci may have funded the fresco program via the sale of three houses in 1423–25 and (possibly) with embezzled public funds.

50. Astrid Debold von Kritter, "Studien zum Petruszyklus in der Brancaccikapelle" (unpublished Ph.D. disserta-

tion, Frei Universität Berlin, 1975), pp. 159ff.; Pope-Hennessy (note 49), pp. 34–38.

51. The actual sequence of the frescoes can be measured by the overlay of individual *giornate* (a *giornata* is a day's patch of true fresco work, which would slightly overlap a previous, adjacent patch). In the case of the chapel's two lower levels, the sequence of *giornate* indicates that work began on the altar wall and proceded outward to the lateral walls.

52. Pope-Hennessy (note 49), p. 44; Keith Christiansen, "Some Observations on the Brancacci Chapel Frescoes after Their Cleaning," *Burlington Magazine* 133 (January 1991), pp. 18–19.

53. As first pointed out by Robert Oertel, "Masaccio und die Geschichte der Freskotechnik," *Jahrbuch der preussischen Kunstsammlungen* 55 (1934), pp. 234–236.

54. Pope-Hennessy (note 49), p. 40, and Christiansen (note 52), p. 12.

55. Luciano Bellosi, as reported in Luciano Berti, *Masaccio* (Florence, 1988), pp. 44–45.

56. Longhi, "Fatti di Masolino e di Masaccio," *Critica d'arte* 5 (July–December 1940), pp. 160–161.

57. Paul Joannides, "Masaccio's Brancacci Chapel: Restoration and Revelation," *Apollo* 133 (January 1991), p. 27.

58. Miklòs Boskovits, "Il percorso di Masolino: Precisazione sulla cronologia e sul catalogo," *Arte cristiana* 75 (March–April 1987), pp. 55–56.

59. Vasari (note 13), pp. 298–299.

60. Masaccio's pioneering role was noted shortly after his death in Alberti's introduction to his *Della pittura* (note 36), p. 39), which included among other dedicatees Donatello and Brunelleschi.

61. Author's translation. For Landino's original text, see Michael Baxandall, *Painting and Experience in Fifteenth Century Italy* (Oxford, 1972), p. 118.

62. Joannides, *Masaccio and Masolino* (note 3), pp. 443–446, no. L3. For an extended discussion of the *Sagra's* possible patron and of the event depicted, see Megan Holmes, *Fra Filippo Lippi, the Carmelite Painter* (New Haven and London, 1999), pp. 42–50.

63. Vasari (note 13), pp. 295–297.

64. Joannides, *Masaccio and Masolino* (note 3), p. 446.

65. Joannides, *Masaccio and Masolino* (note 3), p. 443.

66. Joannides, *Masaccio and Masolino* (note 3), pp. 356–368, no. 14.

67. Vasari (note 13), p. 33. For a well-argued instance of this view, see Ralph Lieberman, "Brunelleschi and Masaccio in Santa Maria Novella," *Memorie domenicane*, N.S., 12 (1981), pp. 127–139.

68. Jack Freiberg, "The Tabernaculum Dei: Masaccio and the 'Perspective Sacrament Tabernacle'" (master's thesis, New York University, 1976), pp. 10–11. It is also possible that Brunelleschi's achievement may have been known to Masaccio via Donatello, whose classical framing for the niche of his *Saint Louis of Toulouse* statue has parallels with Masaccio's architectural design (see Joannides, *Masaccio and Masolino* [note 3], p. 366).

69. On the Eucharistic message of Masaccio's fresco, see especially Freiberg (note 68), pp. 19–22, and Eve Borsook, *The Mural Painters of Tuscany*, 2d ed., rev. (Oxford, 1980), p. 58.

70. Joannides, *Masaccio and Masolino* (note 3), pp. 414–422, no. 23; see also Carl Brandon Strehlke and Mark Tucker, "The Santa Maria Maggiore Altarpiece," in Strehlke and Frosinini (note 7), pp. 111–129.

71. See Strehlke and Tucker (note 70), pp. 115–118.

72. Joannides, *Masaccio and Masolino* (note 3), p. 418.

73. Vasari (note 13), p. 300.

74. Author's translation. For Vasari's original text, see Luciano Bellosi and Aldo Rossi, eds., *Giorgio Vasari, Le Vite de' più eccellenti architetti, pittori et scultori italiani, nell'edizione per i tipi di Lorenzo Torrentino, Firenze 1550* (Turin, 1986), pp. 268–269.

75. In 1561 Vasari advised on a new arrangement of chapels for Pisa cathedral. That same year, he began the design of the Piazza dei Cavalieri, the Palazzo dei Cavalieri, and the church of Santo Stefano. On Vasari and Pisa, see T. S. R. Boase, *Giorgio Vasari, the Man and the Book* (Princeton, 1979), pp. 158, 162, and Leon Satkowski, *Giorgio Vasari: Architect and Courtier* (Princeton, 1993), pp. 67–74.

76. Author's translation. For the original text, see Vasari (note 13), p. 292.

77. Archivio di Stato di Pisa, Archivio dell'Opera del Duomo, Archivi privati, mss. 1305 (the ledger entitled "Possessioni, debitori e creditori e ricordi di Giuliano di Colino degli Scarsi, notaio, da San Giusto 1422–1454") and 1306 (the account book entitled "Debitori e creditori di Giuliano di Colino degli Scarsi, notaio, da San Giusto"). Both documents were first published, in partial form, by L. Tanfani Centofanti, *Donatello in Pisa* (Pisa, 1887), pp. 3–7, and *Notizie di*

*artisti tratte dai documenti pisani* (Pisa, 1897), pp. 176–181; later by Giuseppe Poggi, "La tavola di Masaccio pel Carmine in Pisa," in *Miscellanea d'arte* 1 (1903), pp. 36–37 (offprint); and finally in extenso by Beck (note 12), pp. 17–23, Documents XIV, XVI–XVII, XIX, XXI–XXV; pp. 31–50, Appendix Documents 1–14 (the latter drawn from the above-mentioned manuscripts but including payments only for artists working on the altarpiece other than Masaccio). A thorough exegesis, based on a study of the manuscripts themselves, was left to Christa Gardner von Teuffel, "Masaccio and the Pisa Altarpiece: A New Approach," *Jahrbuch der Berliner Museen* 19 (1977), pp. 23–68 (for the documents themselves, see Appendix, pp. 63–68).

78. Beck (note 12), pp. 17–18, Document XV.

79. This has been proposed most recently by Jill Dunkerton and Dillian Gordon, "The Pisa Altarpiece," in Strehlke and Frosinini (note 7), p. 93. By contrast, Strehlke (note 42), p. 19, maintains "that the angels at the bottom . . . were probably never full-length figures."

80. Richard Offner, verbally, 1929, as transcribed on Frick Art Reference Library photograph mount, Masaccio 707–9a.

81. According to Dillian Gordon (*National Gallery Catalogues: Earlier Italian Schools, The Fifteenth Century* [forthcoming, 2003]), the foreshortened elliptical halo of the Christ Child is "unprecedented."

82. Joannides, "Masaccio, Masolino and Minor Sculpture" (note 3), p. 11, and Joannides, *Masaccio and Masolino* (note 3), pp. 160, 387.

83. Poggi (note 77), p. 35. Aside from the version illustrated here, two others are preserved at the Victoria & Albert Museum, London, one in polychromed stucco and the other in marble.

84. Janson (note 2), I, p. 242. For a recent discussion of the Michael Hall relief, see entry by Andrew Butterfield in *Early Renaissance Reliefs*, exh. cat. (New York, Salander-O'Reilly Galleries, 2001), no. 1.

85. Beck (note 12), pp. 19–20, Document XIX (payment of July 24, 1426).

86. Beck (note 12), p. 21, Document XXI (payment of October 15, 1426).

87. Pope-Hennessy (note 2), p. 127.

88. Franco Borsi and Stefano Borsi, *Masaccio*, trans. from the Italian by Odile Ménegaux et al. (Paris, 1998), p. 73.

89. John Shearman, "Masaccio's Pisa Altarpiece: An Alternative Reconstruction," *Burlington Magazine* 108 (September 1966), p. 455, n. 29.

90. Gardner von Teuffel (note 77), p. 43, n. 60. On the Naples *Crucifixion*, see entry in Joannides, *Masaccio and Masolino* (note 3), pp. 389–391, and Pierluigi Leone De Castris, *Museo Nazionale di Capodimonte: Dipinti dal XIII secolò al XVI secolo. Le collezioni borboniche e post-unitarie* (Naples, 1999), pp. 66–68. On all four of its sides, the painting lacks its *barbe*, which, according to Bellucci et al. (note 7), p. 170, would have been about 4.5 cm wide.

91. Ugo Procacci, *All the Paintings of Masaccio*, trans. by Paul Colacicchi (New York, 1962), p. 14.

92. Joannides, *Masaccio and Masolino* (note 3), p. 170.

93. In contrast to the two reconstructions of Gardner von Teuffel (note 77), p. 61, fig. A, and Berti and Foggi (note 11), p. 47, in which the Getty panel appears just to the right of the Naples *Crucifixion*, Joannides, *Masaccio and Masolino* (note 3), p. 389, rightly hypothesizes its original placement at far right.

94. Bellucci et al. (note 7), p. 190; see also the discussion in Strehlke (note 42), p. 21; Dunkerton and Gordon (note 79), pp. 94–95; and Gordon (note 81).

95. Ser Giuliano's father and mother died in 1417 and 1419, respectively (Beck [note 12], p. 32, Appendix Document 1).

96. Gardner von Teuffel (note 77), p. 52. See also Joannides, *Masaccio and Masolino* (note 3), pp. 384–385.

97. See Marta Battistoni, *Giuliano di Colino degli Scarsi, Operaio del Duomo di Pisa (1435–1456)* (Pontedera, 1999), pp. 29 (genealogical chart), 38.

98. See Borsook (note 1), p. 212, who writes "Giovanni Pisano's concentration of strong feeling into essential shapes and masses must have struck a chord in Masaccio, because his feeling, a century later, was much the same."

99. August Schmarsow, *Masolino und Masaccio* (Leipzig, 1928), pp. 160–161.

100. Beck (note 12), p. 21, Document XXI.

101. Beck (note 12), p. 22, Document XXIII. At this time Ser Giuliano records Donatello's presence as a witness.

102. Beck (note 12), p. 22, Document XXIV.

103. For documentation, see Jeffrey Ruda, *Fra Filippo Lippi: Life and Work with a Complete Catalogue* (London, 1993), pp. 513–515, and Holmes (note 62), pp. 13–19.

104. Artur Rosenauer, "Filippo Lippi giovanissimo," in Ornella Francisci Osti, ed., *Mosaics of Friendship: Studies in Art and History for Eve Borsook* (Florence, 1999), pp. 175–185.

105. Miklòs Boskovits, "Fra Filippo Lippi, i Carmelitani e il Rinascimento," in *Immagini da meditare: Ricerche su dipinti di tema religioso nei secoli XII–XV* (Milan, 1994), p. 429. This article first appeared in a slightly different version in *Arte cristiana* 74 (September–October 1986), pp. 47–66.

106. Rosenauer (note 104), pp. 182–183. The same point was also made, though more tentatively, by Joannides, *Masaccio and Masolino* (note 3), pp. 255, 333. For the technical evidence supporting this hypothetical example of subcontracted work, involving a *giornata* otherwise painted by Masaccio, see John T. Spike, *Masaccio* (New York, 1995), p. 179.

107. Joannides (note 57), p. 29.

108. Ruda (note 103), p. 514.

109. Vasari (note 13), pp. 292–293. Although the fresco, "next to the door that leads to the monastery," was said to be by Masaccio, Vasari firmly maintained an attribution to Lippi. In the 1550 edition of *Le vite*, however, he held the majority view, describing its subject as "an Apostle" (Bellosi and Rossi [note 74], p. 268). The fresco is not mentioned in Ruda (note 103).

110. Besides the reconstructions listed in Gardner von Teuffel (note 77), p. 24, n. 4, see that author's (pp. 29–34, 38–49) and that of Foggi in Berti and Foggi (note 11), p. 47. I was able to reconsider some of the questions involving the original appearance of the Pisa Altarpiece (as well as ones involving matters of attribution) thanks to the exhibition of all of the known components of the altarpiece held in honor of the 600th anniversary of Masaccio's birth at the National Gallery, London (September 12–November 11, 2001), curated by Dillian Gordon and Jill Dunkerton.

111. Shearman (note 89), pp. 449–455.

112. Gardner von Teuffel (note 77), pp. 30, 38.

113. Beck (note 12), p. 31, Appendix Document 1. The order of precedence of this summary record of payments was commented on by Shearman (note 89), p. 450, n. 14, but questioned most recently by Joannides, *Masaccio and Masolino* (note 3), p. 383. Antonio di Biagio, none of whose work is known, is last recorded in 1444. See M. Fanucci Lovitch, *Artisti attivi a Pisa fra XIII e XVIII secolo*, vol. 1 (Pisa, 1991), p. 20. For a transcription of his 1427 *catasto*, see Christoph Merzenich, *Vom Schreinerwerk zum Gemälde: Florentiner Altarwerke der ersten Hälfte des Quattrocento: Eine Untersuchung zu Rekonstruktion, Material und Rahmenform* (Berlin, 2001), p. 135. There appears to be no basis for the claim by

Hellmut Wohl ("Masaccio," in *The Dictionary of Art* [London, 1996], vol. 20, p. 31) that the "last payment [to Antonio] was recorded on the same day, 19 February 1426, as the first payment to Masaccio."

114. Beck (note 12), p. 32, Appendix Document 1.

115. See discussion in Shearman (note 89), p. 453, n. 18. On Francesco d'Antonio, see entry by Bruce Edelstein in *Dizionario biografico degli italiani* 49 (Rome, 1997), pp. 658–659.

116. Shearman (note 89), pp. 450–454.

117. Although it has recently been determined that the paint surface and tooling of the above-mentioned wings are actually modern (see Gordon [note 81]), these motifs can be said to replicate Masaccio's original design.

118. In preparation for the great "L'Età di Masaccio" exhibition (Florence, Palazzo Vecchio, *L'Età di Masaccio: Il primo quattrocento a Firenze* [1990], p. 188, no. 64), the picture was lightly cleaned and given a wooden "prosthesis" at the panel's top, thereby replicating the tripartite Gothic arch that had originally capped the composition.

119. For this panel, see entry by Everett P. Fahy in Maria Teresa Filieri, ed., *Sumptuosa tabula picta: Pittori a Lucca tra gotico e rinascimento*, exh. cat. (Lucca, Museo Nazionale di Villa Guinigi, 1998), pp. 380–381, no. 53. On Borghese di Piero, see the biographical essay by Maria Teresa Filieri in ibid., pp. 370–372.

120. Fanucci Lovitch (note 113), p. 58.

121. Joannides, *Masaccio and Masolino* (note 3), pp. 385–387.

122. Beck (note 12), p. 49, Appendix Document 13 (payment of July 23, 1428).

123. Beck (note 12), pp. 18–23, Documents XVI–XVII, XIX, XXI–XXV.

124. Strehlke (note 42), p. 17. For the technical evidence itself, see Bellucci et al. (note 7), p. 170.

125. Strehlke (note 42), pp. 16, 18, a hypothesis seconded by Bellucci and Frosinini (note 20), pp. 53–54.

126. Merzenich (note 113), p. 88.

127. For the following proposal I am greatly indebted to Laurence B. Kanter, curator, Robert Lehman Collection, Metropolitan Museum of Art, who kindly shared with me his exceptional knowledge of early Italian altarpiece design.

128. For examples, see Merzenich (note 113), figs. 97, 101, 105, 117.

129. For the description of Chinzica quoted above, which dates from 1422 and has been attributed to Ranieri Sardo, see Igino Benvenuto Supino, *Arte pisana* (Florence, 1904), p. 311. For the map illustrated here (Siena, Matteo Florimi, n.d.), see Emilio Tolaini, *Forma Pisarum: storia urbanistica della città di Pisa*, 2d ed., rev. (Pisa, 1979), p. 197. On Santa Maria del Carmine, see Franco Paliaga and Stefano Renzoni, *Le Chiese di Pisa. Guida alla conoscenza del patrimonio artistico* (Pisa, 1991), pp. 127–132.

130. That the location of the present long walls match essentially those of the fifteenth-century church can be deduced by two factors: the varying stages of brickwork visible on the elevation of the northern wall as it faces the Via del Carmine and the existence of late-fourteenth-century frescoed remains on the other side of the south wall, which faces the adjacent cloister (for which, see Antonio Augusto Canal, *Carmine/Carmelitani e Carmelitane a Pisa* [Pisa, 1987], pp. 5–7, 22–25).

131. On the *tramezzo* in Renaissance Italy, see Marcia B. Hall, "The *Ponte* in S. Maria Novella: The Problem of the Rood Screen in Italy," *Journal of the Warburg and Courtauld Institutes* 37 (1974), pp. 157–173; and idem, *Renovation and Counter-Reformation: Vasari and Duke Cosimo in Sta Maria Novella and Sta Croce, 1565–1577* (Oxford, 1979), pp. 2–20.

132. For this example, see, most recently, Laurence B. Kanter, *Italian Paintings in the Museum of Fine Arts, Boston*, vol. I, *Thirteenth–Fifteenth Century* (Boston, 1994), pp. 211–214, no. 66. No other depictions of an altarpiece attached to a *tramezzo*, Renaissance style or otherwise, appear in the recent compendium of Stefan A. Horsthemke, *Das Bild im Bild in der italienischen Malerei: Zur Darstellung religiöser Gemälde in der Renaissance* (Glienicke, 1996), pp. 29–56, 181–204.

133. Translation by Gordon (note 81). For the original text, see Beck (note 12), p. 36, Appendix Document 3.

134. Joannides, *Masaccio and Masolino* (note 3), p. 384.

135. Letter to the author, June 6, 2001.

136. From a summary of payments to Pippo di Giovanni dated October 14–19, 1426, for which see Beck (note 12), p. 39, Appendix Document 5. Hall (note 131), p. 168, n. 32, wrongly translates "una crociera di marmo" as a marble cross set upon the altar.

137. Beck (note 12), p. 39, Appendix Document 3.

138. Summary of payments to Pippo di Giovanni, dated October 14–19, 1426. See Beck (note 12), p. 39, Appendix Document 5. For the width of the entire predella, see above, p. 47.

139. Gardner von Teuffel (note 77), pp. 59–61.

140. Pippo was paid for such work on June 5, 1428; see Beck (note 12), p. 44, Appendix Document 10, item 4; p. 45, Appendix Document 10, item 6.

141. Beck (note 12), p. 42, Appendix Document 7, item 10 (payment to Pippo di Giovanni); p. 22, Document XXV (payment of December 26, 1426, to Masaccio).

142. Beck (note 12), p. 45, Appendix Document 10, item 7; Appendix Document 11, item 1.

143. Beck (note 12), p. 45, Appendix Document 10, item 5.

144. Beck (note 12), p. 46, Appendix Document 12, item 4.

145. Beck (note 12), p. 46, Appendix Document 12, item 3 (undated document but locatable to 1428). Cola (or Niccolò) di Antonio entered the Compagnia di San Luca in Florence in 1417. However, according to Enzo Carli, *La pittura a Pisa dalle origini alla "bella maniera"* (Pisa, 1994), p. 162, Cola had already transferred to Pisa in 1412. Works by Cola either are lost or remain unidentified.

146. Beck (note 12), p. 32, Appendix Document 1, item 8 (original payment document lost; this notice from Ser Giuliano's summary of payments).

147. Beck (note 12), p. 49, Appendix Document 13; see also Ser Giuliano's later summary of payments (p. 32, Appendix Document 1, item 6).

148. Beck (note 12), p. 45, Appendix Document 11, item 1.

149. Payment of 40 lire to Pippo di Giovanni dated March 17–19, 1427 (Beck [note 12], p. 42, Appendix Document 8, item 1).

150. Archivio di Stato di Pisa, Archivio dell'Opera del Duomo, Archivi privati, MS 1305, fols. 11r, 20r, 21r; published in Gardner von Teuffel (note 77), p. 64. For other donations of land, see p. 65.

151. Merzenich (note 113), p. 79.

152. John R. Spencer, trans. and ed., *Filarete's Treatise on Architecture, Being the Treatise by Antonio di Piero Avelino, Known as Filarete* (New Haven and London, 1965), vol. I, pp. 15–16, 18. Composed in 1461–1464, the treatise lists Masaccio among several "good masters" of the previous generation (p. 120).

153. As first proposed by Richard Offner, "Light on Masaccio's Classicism," in *Studies in the History of Art Dedicated to William E. Suida on His Eightieth Birthday* (London, 1959), pp. 71–72.

154. For this point, see Charles Hope, "Altarpieces and the Requirements of Patrons," in Timothy Verdon and John Henderson, eds., *Christianity and the Renaissance: Image and Religious Imagination in the Quattrocento* (Syracuse, New York, 1990), p. 551.

155. Battistoni (note 97), p. 13.

156. Gardner von Teuffel (note 77), p. 26. For Giuliano's tax assessment, with a list of dependents, see Beck (note 12), pp. 24–29, Documents XXVII–XXVIII.

157. Battistoni (note 97), pp. 23, n. 13; 17.

158. Battistoni (note 97), pp. 7, 16–17.

159. For this figure, see Battistoni (note 97), pp. 35–36.

160. Battistoni (note 97), pp. 36–37; 53, n. 39; 87.

161. Giuseppe Petralia, "'Crisi' ed emigrazione dei ceti eminenti a Pisa durante il primo dominio fiorentino," in Donatella Rugiadini, ed., *I ceti dirigenti nella Toscana del quattrocento . . . atti del V e VI Convegno, Firenze, 10–11 dicembre 1982, 2–3 dicembre 1983* (Florence, 1987), p. 336.

162. For the importance of notaries in medieval Italy, see Daniel P. Waley, *The Italian City-Republics* (London, 1969), p. 29.

163. Keith Christiansen, *Gentile da Fabriano* (Ithaca, N.Y., 1982), pp. 50–55; 137, cat. no. LVI. That the painting's medium was indeed fresco has been ascertained by Andrea De Marchi, *Gentile da Fabriano: Un viaggio nella pittura italiana alla fine del Gotico* (Milan, 1992), p. 194.

164. See G. Sarti, *Primitifs et maniéristes italiens (1370–1570)*, exh. cat. (Paris, G. Sarti, 2000), pp. 14–23, no. 1.

165. Pisa's population declined from 2,816 hearths in 1407 to 1,779 in 1412. In 1427, it declined to 1,752 (David Herlihy and Christiane Klapisch-Zuber, *Tuscans and Their Families: A Study of the Florentine Catasto of 1427* [New Haven and London, 1985], p. 72). Florence tried to counter this downturn by encouraging immigration, but to little effect (Bruno Cassini, *Aspetti della vita economica e sociale di Pisa dal catasto del 1428–1429* [Pisa, 1965], p. 79). For the history of Pisa at this time, see especially Ranieri Grassi, *Descrizione storica e artistica di Pisa e de' suoi contorni*, vol. 3 (Pisa, 1836), pp. 216–226, and Michael Mallett, "Pisa and Florence in the Fifteenth Century: Aspects of the Period of the First Florentine Domination," in Nicolai Rubinstein, ed., *Florentine Studies: Politics and Society in Renaissance Florence* (London, 1968), pp. 403–444.

166. Mallett (note 165), pp. 78–80, 106. On the number of notaries in Tuscany in 1427, see Herlihy and Klapisch-Zuber (note 165), p. 128, Table 4.7, "The Ten Most Numerous Occupations in the Tuscan Towns." The occupation of notary leads the list for Florence, while in Pisa it was second to that of shoemaker. On the subservience of the Pisan guilds to those of Florence, see Pietro Silva, "Pisa sotto Firenze dal 1406 al 1433 (con appendice di documenti)," *Studi storici* 18 (1909–1910), pp. 297–301.

167. Legislation to this effect was passed in 1416 (Raffaele Ciasca, *Statuti dell'Arte dei Medici e Speziali* [Florence, 1922], p. 413).

168. For the untraced San Michele paintings, see Vasari (note 13), p. 21. A drawing in the Robert Lehman Collection at the Metropolitan Museum of Art, which has been attributed to Lorenzo Monaco and dated to ca. 1420, is partially inscribed ". . . PISA." See entry by Laurence B. Kanter in *Painting and Illumination in Early Renaissance Florence, 1300–1450*, exh. cat. (New York, Metropolitan Museum of Art, 1994–1995), pp. 299–300, no. 40.

169. For illustrations, see Richard Fremantle, *Florentine Gothic Painters from Giotto to Masaccio* (London, 1975), figs. 884, 892.

170. On the hypothetical provenance of Gentile's Pisa *Madonna*, see entry by Mariagiulia Burresi in *Imago Mariae: Tesori d'arte della civiltà cristiana* exh. cat. (Rome, Palazzo Venezia, 1988), no. 55.

171. For this painting (now in the Museo Nazionale e Civico di San Matteo, Pisa), see Carli (note 145), pp. 163–164. Its original destination was presumably the chapel to the left of the choir, which was dedicated to Saint Eulalia. (On this dedication, see Canal [note 130], pp. 16–17.) On January 23, 1427, Masaccio had acted as a witness to the transfer of ownership of this chapel from the Dal Poggio family back to the Carmelite community, which in turn ceded it to the Catalan merchants confraternity, whose patron saint was Eulalia. See Fanucci Lovitch (note 113), p. 206.

172. Ugo Procacci, "L'uso dei documenti negli studi di storia dell'arte e le vicende politiche e economiche in Firenze durante il primo quattrocento nel loro rapporto con gli artisti," in *Donatello e il suo tempo: Atti dell'VIII Convegno internazionale di studi sul Rinascimento, Florence/Padova, 25 settembre–1 ottobre 1966* (Florence, 1968), pp. 37–38.

173. The ostensible reason for Michelozzo's and Donatello's move to Pisa was its port location, since their main project at hand, the tomb of Cardinal Rainaldo Brancaccio, could be sent from there directly to its final destina-

tion, Naples. On that project, see Ronald W. Lightbown, *Donatello and Michelozzo* (New Haven and London, 1980), vol. 1, pp. 83–127. For the view that Donatello had already established a base in Pisa in 1425, instead of in 1426, as usually maintained, see Carli (note 145), p. 161.

174. According to folio 20v of Ser Giuliano's "Libro di possessioni, 1424–1454," work on his chapel began in 1414 (old style, 1415). See Gardner von Teuffel (note 77), p. 64.

175. Beck (note 12), p. 44, Appendix Document 10; p. 46, Appendix Document 12, item 4.

176. Paliaga and Renzoni (note 129), p. 157.

177. Archivio di Stato di Firenze, Notarile antecosimiano, 15761 (Ser Antonio di Giusto dall'Orto, 1445–1451), beginning on fol. 259r. Ser Giuliano's will is cited in Battistoni (note 97), p. 98, n. 132. I wish to thank Rolf Bagemihl, for transcribing sections of it, and Frank Dabell, for expertly explicating and translating portions thereof.

178. The Doctrine of Origin appears in the order's constitution of 1324 as well as in contemporary writings, for which see O. Stegginck, "Carmelitani: II. Spiritualità," in *Dizionario degli istituti di perfezione*, vol. 2 (Rome, 1975), col. 480. See also the excellent account in Holmes (note 62), p. 171.

179. On early-fourteenth-century Carmelite historiography, see Joanna Cannon, "Pietro Lorenzetti and the History of the Carmelite Order," *Journal of the Warburg and Courtauld Institutes* 50 (1987), pp. 24–28, and Creighton E. Gilbert, "Some Special Images for Carmelites, circa 1330–1430," in Verdon and Henderson (note 154), p. 164.

180. Ludovico Saggi, "Carmelitani," in *Dizionario degli istituti di perfezione*, vol. 2 (Rome, 1975), col. 460, and Holmes (note 62), pp. 74–79. Besides the extensive bibliography on the order cited by Gardner von Teuffel (note 77), p. 27, n. 16, see Peter-Thomas Rohrbach, *Journey to Carith: The Story of the Carmelite Order* (Garden City, N.Y., 1966), Carlo Cicconetti, *La Regola del Carmelo. Origine, natura, significato* (Rome, 1973), and Joachim Smet, *The Carmelites: A History of the Brothers of Our Lady of Mount Carmel*, 4 vols. (Darien, Ill.), 1975–1985.

181. Rohrbach (note 180), pp. 63–65.

182. Gardner von Teuffel (note 77), p. 28. The Tuscan province comprised houses in Florence, Lucca, Pisa, Pistoia, Prato, Montecatini, and Le Selve (near Signa, west of Florence), whereas the Siena and Arezzo houses, although located in Tuscany, belonged to the province of Rome (see idem, p. 53).

183. Andrea Sabatini, ed., *Atti di capitoli provinciali di Toscana dei Carmelitani, 1375–1491* (Rome, 1975). The first study

of these records in relation to Carmelite paintings is Miklòs Boskovits (note 105), pp. 397–435.

184. The two friars witnessed payments to Masaccio on February 20 and March 23, 1426 (Beck [note 12], pp. 18–19, Documents XVI–XVII).

185. Beck (note 12), p. 39, Appendix Document 5 (summary of payments to Pippo di Giovanni, dated October 14–19, 1426).

186. Ser Giuliano's words are "la taula mi debbia consegnare compiuta a loda di dicto maestro Antone" (Beck [note 12], pp. 22, 35). Although *loda* translates as "praise," it is probable that the word *lodo*, or "agreement," was actually intended (verbal suggestion of Cecilia Frosinini, as cited in Gordon [note 81]).

187. Sabatini (note 183), pp. 77, 80, 83, 88, 90, 93. For more on Fra Antonio di Matteo, see Gardner von Teuffel (note 77), pp. 28–29.

188. "Flos Carmeli, Vitis florigera, Splendor celo virgo puerpea / Singularis Mater mitis. Set viri nescia Carmelitis / Da Privilegia, Stella Maris." (English translation courtesy Fathers Mark Hallanan, S.J., and Robert O'Brien, S.J., St. Ignatius of Loyola, New York, N.Y.) For the above discussion, see Gardner von Teuffel (note 77), pp. 56–57.

189. Gerard David's painting was presented by the artist to the Carmelite convent of Sion, near Brussels, in 1509. For this and other examples of Carmelite works of art with related iconography, see Gardner von Teuffel (note 77), p. 57 and n. 97.

190. Luke 1:17: "And he shall go before him [God] in the spirit and power of Elias [i.e., Elijah]."

191. Sabatini (note 183), p. 122.

192. Frederick Antal, *Florentine Painting and Its Social Background* (London, 1947), p. 346, n. 19. This opinion was repeated by Mario Salmi, *Masaccio*, 2d ed., rev. (Milan, 1948), p. 139; Beck (note 12), p. 19; and Bellucci and Frosinini (note 20), p. 49.

193. Sabatini (note 183), p. 157.

194. Sabatini (note 183), pp. 153–154.

195. For the Ascension play at Santa Maria del Carmine, see Richard C. Trexler, *Public Life in Renaissance Florence* (New York, 1980), pp. 454–475, and Cyrilla Barr, "Music and Spectacle in Confraternity Drama of Fifteenth-Century Florence: The Reconstruction of a Theatrical Event," in Verdon and Henderson (note 154), pp. 376–404.

196. Sabatini (note 183), pp. 159, 164, 169. The feast day of the Ascension was a movable one, falling on June 24 in 1424, May 9 in 1426, and May 13 in 1428.

197. For this point, see, for example, Christiansen (note 52), p. 16.

198. Gilbert (note 179), pp. 166–180. See also Carlo Volpe, *Pietro Lorenzetti*, ed. by Mauro Lucco (Milan, 1989), pp. 135–149.

199. For a recent account of the fresco's imagery, see Holmes (note 62), pp. 68–79.

200. Vasari (note 13), p. 613.

201. Holmes (note 62), p. 74.

202. Holmes (note 62), pp. 65–66.

203. Keith Christiansen, "Three Dates for Sassetta," *Gazette des Beaux-Arts* 114 (December 1989), pp. 263–264. On the altarpiece, see Keith Christiansen in *Painting in Renaissance Siena, 1420–1500*, exh. cat. (New York, Metropolitan Museum of Art, 1989), pp. 64–79; Gilbert (note 179), pp. 180–192; and Machtelt Israëls, "Sassetta's Arte della Lana Altarpiece and the Cult of Corpus Domini in Siena," *Burlington Magazine* 143 (September 2001), pp. 532–543.

204. Israels (note 203), p. 538.

205. See the historical study of Piero Scapecchi, *La pala dell'Arte della Lana del Sassetta* (Siena, 1979).

206. For a discussion of this and other Carmelite commissions, see especially Holmes (note 62), pp. 29–42; Gardner von Teuffel (note 77), pp. 53–54; and Gilbert (note 179), passim.

207. Holmes (note 62), p. 36.

208. Although the frame on the Yale altarpiece is said to be modern, the inscriptions (including the date of April 15, 1420) presumably copy those on the lost, original one. See Charles Seymour, Jr., *Early Italian Paintings in the Yale University Art Gallery: A Catalogue* (New Haven and London, 1970), pp. 112, 114. For the attribution to Ventura di Moro, see Kanter (note 132), p. 149, n. 1.

209. Vasari (note 13), p. 41.

210. See entry by Carl Brandon Strehlke in *Painting in Renaissance Siena, 1420–1500*, exh. cat. (New York, Metropolitan Museum of Art, 1988), pp. 250–254, no. 41.

211. Boskovits (note 105), pp. 407–408.

212. Fahy (note 119), p. 326, no. 44.

213. Both Spike (note 106), p. 200, and Richard Fremantle (*Masaccio: Catalogo completo* [Florence, 1998], p. 114) wrongly state that Masaccio's contract survives.

214. Beck (note 12), p. 21, Document XXI.

215. Paliaga and Renzoni (note 129), pp. 127–132.

216. Hall, *Renovation and Counter-Reformation* (note 131), p. 2, n. 3. As with Santa Maria del Carmine in Pisa, the Florentine church's *tramezzo* also included altars, some with accompanying altarpieces.

217. Ranieri Grassi, *Descrizione storica e artistica di Pisa e de' suoi contorni*, vol. 2 (Pisa, 1838), p. 166.

218. See Mariagiulia Burresi and Antonino Caleca's entry for the *Saint Paul* in Mariagiulia Burresi, ed., *Nel secolo di Lorenzo: Restauri di opere d'arte del Quattrocento*, exh. cat. (Pisa, Museo Nazionale e Civico di San Matteo), pp. 92–96, no. 13.

219. See Paolo Tronci, "Libro di ricordi," ca. 1640 (Archivio di Stato di Pisa, Acquisto Monino, MS 4), who describes among his paintings "Il S. Paolo Apostolo in tavola è di mano di Masaccio di Valdarno cavata dal Carmine donatomi dal signor Decano Francesco Berzighelli; fiorì questo pittore famoso l'anno 1430." On this important early source, see Dino Frosini, "Il libro di ricordi e il collezionismo di Paolo Tronci," *Bollettino storico pisano* 49 (1980), pp. 177–195.

220. Paolo Tronci, "Notizie delle chiese pisane," ca. 1643 (Archivio Capitolare, MS C151), fol. 24v. See also Paliaga and Renzoni (note 129), pp. 130–131. On the Berzighelli family, see Bruno Casini, *Il "Priorista" e i "libri d'oro" del comune di Pisa* (Florence, 1986), pp. 176–177.

221. According to Alessandro Da Morrona, *Pisa illustrata nelle arti del disegno*, 2d ed., rev. (Livorno, 1812), vol. 3, p. 275, the altarpiece was executed by a pupil of Santi di Tito called Baccio Ciarpi (1574–1654); however, according to Tronci (note 220), fol. 24v; Paliaga and Renzoni (note 129), pp. 130–131; and Simonetta Prosperi Valenti Rodinò, "Ciarpi, Lorenzo Bartolomeo [Baccio]," in *Dizionario biografico degli italiani*, vol. 25 (Rome, 1981), p. 221, it should instead be attributed to Santi di Tito. The painting is omitted in Jack Spalding, *Santi di Tito* (New York and London, 1982).

222. Roberto Longhi, "Una 'riconsiderazione' dei primitivi italiani a Londra," *Paragone* 183 (May 1965), p. 14. For the unsubstantiated notion that Masaccio's altarpiece "had disappeared from the church of the Carmine in 1750," see Joseph Archer Crowe and Giovanni Battista Cavalcaselle, *History of Painting in Italy, Umbria, Florence, and Siena, from the Second to the Sixteenth Century*, ed. by Robert Langton Douglas

and Giacomo De Nicola, vol. 4 (London, 1911), p. 61, editors' n. 1. To this, Douglas adds cryptically "there are grounds for believing that portions of it were kept in the convent."

223. Federico Fantozzi, *Nuova guida ovvero descrizione storico-artistico-critica della città e contorni di Firenze* (Florence, 1846), pp. 398–399. In later years, the Palazzo Gino Capponi was owned by the early collector of Cézanne paintings Egisto Fabbri and the major dealer in old master paintings during the Fascist and immediate postwar eras, Count Alessandro Contini Bonacossi. For further information on Capponi's collection, see Elizabeth E. Gardner, *A Bibliographical Repertory of Italian Private Collections*, vol. 1, *Abaco—Cutolo*, ed. by Chiara Ceschi and Katharine Baetjer (Vicenza, 1998), pp. 190–191.

224. London, Christie's, *Catalogue of the Second Portion of the Valuable and Extensive Collection of Pictures, of Thomas Blayds, Esq., of Castle Hill, Englefield Green . . .* , March 30, 1849, lots 183 (an altarpiece, by Taddeo di Bartolo), 201 (a Holy Family attributed to Lorenzo di Credi), 208 (an altarpiece by Neri di Bicci), 210 (a Madonna and Child with Infant Saint John attributed to Fra Bartolomeo), and 211 (a tondo attributed to Botticelli). Almost nothing is known of Blayds and the formation of his collection, which, according to the sale catalogue's title page, was assembled "during a Residence in Italy."

225. On this altarpiece of 1389, see Gail E. Solberg, "Taddeo di Bartolo: His Life and Work" (Ph.D. dissertation, New York University, 1991), vol. 5, pp. 1182–1194. The picture is last recorded in a London Sotheby's sale, December 3–4, 1997, lot 56.

226. Leonardo Ginori Lisci, *I palazzi di Firenze nella storia e nell'arte* (Florence, 1972), vol. 1, p. 526.

227. Pompeo Litta, *Famiglie celebri italiane*, vol. 5 (Milan, 1874), "Capponi di Firenze," pl. XXI.

228. Alternatively, there may have been a connection between Gino Capponi and Santa Maria del Carmine through his wife, Giulia, the daughter of marchese Vincenzio Riccardi. Thus, the chapel to the right of the choir (which Gardner von Teuffel mistakenly thinks was the original site of Masaccio's altarpiece) has two Riccardi family tombs, dated 1517 and 1766 respectively (Gardner von Teuffel [note 77], pp. 62–63, n. 125).

229. For this letter, preserved in the private archive of the Palazzo Antinori, Florence, see Giacomo Agosti, "Giovanni Morelli corrispondente di Niccolò Antinori," in *Studi e ricerche di collezionismo e museo-grafia, Firenze 1820–1920* (Pisa, 1985), pp. 72–73.

230. *Cronaca d'oro* (Rome, 1899), p. 420.

231. Agosti (note 229), pp. 72–73.

232. Wilhelm von Bode, *Mein Leben*, ed. by Thomas W. Gaehtgens and Barbara Paul (Berlin, 1997) vol. 1, p. 181. Morelli's guide to the Capponi collection does not appear in the list of his writings compiled by Giacomo Agosti in Matteo Panzeri and Giulio Orazio Bravi, eds., *La figura e l'opera di Giovanni Morelli: Materiali di ricerca* (Bergamo, 1987), vol. 1, pp. 29–30; according to the Morelli specialist Jaynie Anderson (letter to author, March 8, 2000), this unlocatable item may have been in manuscript form, as was one Morelli wrote on the collection of his pupil Gustavo Frizzoni.

233. Some twenty years later, another part of the Pisa Altarpiece, the Naples *Crucifixion*, was briefly considered to be by Masolino when acquired in 1901 (see Leone de Castris [note 90], pp. 66–68).

234. Less than half of these have been published. Twenty-six letters between Morelli and Capponi appear in *Lettere di Gino Capponi* vols. 2–4 (Florence, 1883–1885), ad indicem. There are also forty-three letters to Capponi in the Biblioteca Nazionale Centrale, Florence, Raccolta Capponi, X 7–8.

235. Von Bode (note 232), p. 181. It is not known whether the intermediary here was Stefano Bardini (1836–1922), who was a main conduit for sales to the Berlin museums and also had handled works from the Capponi collection.

236. For example, in 1877 he acquired Benedetto da Maiano's *Bust of Filippo Strozzi* directly from the Palazzo Strozzi in Florence; Von Bode (note 232), p. 131.

237. See Frank Herrmann, *The English as Collectors: A Documentary Sourcebook*, 2d ed., rev. (London and New Castle, Delaware, 1999), pp. 145–147.

238. Wilhelm von Bode, "La Renaissance au Musée de Berlin," part 4, *Gazette des Beaux-Arts*, series 2, 37 (June 1888), pp. 474–475. This identification had already been made by Joseph Archer Crowe and Giovanni Battista Cavalcaselle, *Storia della pittura in Italia*, vol. 2 (Florence, 1883), p. 328.

239. "Alla domanda che mi fai riguardo certi quadri della Galleria Capponi è meglio che non ti risponda verbo. Mi vien proprio la stizza, pensando all'umiliazione che si pensa di arrecare alla memoria dell'ottimo Gino, lasciando andare all'Estero delle opere d'arte preziose come sarebbero quei 4 o 5 quadretti da me indicatiti nell'ultima mia. Non v'ha proprio più senso di dignità nè individuale, nè nazionale in Italia!" (archives, Palazzo Antinori, Florence). I wish to thank Jaynie Anderson for very generously bringing this letter to my attention and for a transcription of it.

240. August Schmarsow, *Masaccio Studien* (Kassel, 1895–1899), 5 vols.

241. Schmarsow (note 240), vol. 2, 1896, pp. 79–80. On this occasion, the same author first published the *Saint Paul*, by then in the museum at Pisa, and the *Saint Andrew*, then belonging to Count Karol Lanckoronski, Vienna (see below).

242. *Exhibition of Early Italian Art, from 1300 to 1550*, exh. cat. (London, New Gallery, 1893–1894), no. 27.

243. Robert C. Witt, *The Nation and Its Art Treasures* (London, 1911), p. 19.

244. According to the archives of the Kaiser-Friedrich-Museum Verein (preserved at the Zentralarchiv, Stiftung Preussischer Kulturbesitz, Berlin), the vendor is described as "Londoner Privatbesitz/London Kunsthandel." Information kindly supplied by Dr. Hannelore Nützmann (telefax to author, August 27, 2001).

245. Denys Sutton, "Robert Langton Douglas, Part II . . . XI. Commerce and Connoisseurship," *Apollo* 109 (May 1979), p. 371.

246. See London, Christie's, *Catalogue of the Very Celebrated & Valuable Series of Capital Pictures, by the Greatest Early Italian Masters, Formed under Singular Advantages, by That Distinguished Connoisseur, the Late Samuel Woodburn, Esq . . . Also, the Reserved Pictures from Mr. Woodburn's Late Residence, in Park Lane*, June 9 and 11, 1860, lot 21 (as Gentile da Fabriano). On Samuel Woodburn, see entry by Harley Preston in *The Dictionary of Art* (London, 1996), vol. 33, p. 345. According to the latter account, Woodburn was assisted in his business by his three brothers, Allen, Henry, and ("more actively") William. Moreover, according to the sale catalogue of the collection of a "Mr. Woodburn, Senior" (London, Christie's, May 12, 1821, title page), their father had been in the art market for "more than forty years." Strangely enough, there is no entry on Samuel Woodburn in the *Dictionary of National Biography*, nor is he the subject of any monograph or (as far as I know) dissertation or thesis.

247. Martin Davies, *National Gallery Catalogues: The Earlier Italian Schools*, 2d ed., rev. (London, 1961), p. 351, n. 19. For the identity of "Miss Woodburn," I am grateful to Dr. Nicholas Penny.

248. MS, London, National Gallery Library, Box AXII/12/6. No. 34 of the notebook is Masaccio's *Madonna and Child with Four Angels*, described there as *"Gentile di* [sic] *Fabriano . // The Virgin & Child, with angels playing musical instruments."*

249. *Art Journal* (April 1, 1850), p. 130.

250. Letter from Gaetano Cristoforo Galeazzi to Tommaso degli Obizzi, April 22, 1800 (Biblioteca Civica, Padua, MS autografi, fasc. 620/c), part of a cache of letters to this collector based in Padua. The relevant text reads as follows: "Avendo veduto un bel Quadro del famoso Masaccio, eccellente Pittore, e perchè per esser morto giovinotto, pochissime son le sue opere, mi venne in testa di cercarne per V.E. giacchè quello veduto, come può dirgli il Sig.r Cap.no si tiene in una chiesa spropositata. Hò avuto la sorte di trovarlo stupendissima, con n°: 6 figure, quando quell'altro non ne ha che una. Non si lascia che per venti Zecchini." I am most grateful to Professor Donata Levi for kindly informing me of this letter, which was discovered, transcribed, and communicated to her by Dr. Gianluca Tormen.

251. According to Roger E. Fry and Maurice W. Brockwell, eds., *A Catalogue of an Exhibition of Old Masters . . . .*, exh. cat. (London, Grafton Galleries, 1911), n.p., no. 7, the painting "is also stated to have been in the Collection of F.H. Sutton in 1864." For further on Canon Sutton, see Nikolaus Pevsner and John Harris, *Lincolnshire*, 2d ed., rev. by Nicholas Antram (London, 1989), pp. 181–183. His diary, cited by Pevsner, remains unpublished, but deals exclusively with Sutton's renovations for the church of Saint Helen's (information kindly provided by Mrs. Valerie Balderson, churchwarden of Saint Helen's; letter to author, January 14, 2000). There are apparently no sources for Canon Sutton's activities as a collector.

252. Davies (note 247), p. 350. On the two Suttons, see also *Burke's Peerage*, 105th ed. (London, 1980), pp. 2593–2594, and *Clergy List* (London, 1902), p. 905.

253. On Berenson's visit to Britain, see Ernest Samuels, *Bernard Berenson: The Making of a Legend* (Cambridge, Mass., and London, 1987), pp. 38–41.

254. Bernard Berenson, "La scoperta di un dipinto di Masaccio," *Rassegna d'arte* 7 (September 1907), p. 139.

255. Bernard Berenson, "La Madonna pisana di Masaccio," *Rassegna d'arte* 8 (May 1908), pp. 81–85.

256. *Palais Lanckoronski, Jacquingasse 18* (Vienna, 1903).

257. Donated by Lanckoronski's son in 1951 to the Kunsthistorisches Museum, Vienna, the Dossi was restituted some three years ago to the Lanckoronski family (Andrea Bayer, Associate Curator of European Paintings, Metropolitan Museum of Art, in conversation, late 2000) and now forms part of the Lanckoronski donation at Wawel Castle in Kraków.

258. W. Koschatzky, *Rudolf von Alt* (Salzburg, 1975), p. 289. Four of von Alt's ten watercolors have recently sold at auction (London, Christie's, June 25, 1998, lots 183–186).

259. Munich, Sotheby's, December 2, 1997, lot 19 (as *Salon eines Kunstsammlers*). This identification was also made, independently, by Jacquin McComish of the National Gallery, London (Dillian Gordon, letter to author, undated [late November 2001]). Although there appears to be no documentation that Count Lanckoronski commissioned this watercolor (and others?), he is known to have owned several by the artist (see *Palais Lanckoronski* [note 256], pp. 4, 21).

260. Jean-Patrice Marandel, "Cachée depuis plus de 50 ans, la célèbre collection Lanckoronski retourne en Pologne," *Connaissance des arts* 524 (January 1996), p. 72.

261. The testimony of the late Countess Karolina is recorded by Dr. Andrew S. Ciechanowiecki, a longtime friend who, as former director of Heim Gallery in London, was responsible for selling the Masaccio on her behalf to the Getty Museum (see his letter to author, October 29, 1999). In Bernard Berenson's *The Study and Criticism of Italian Art* (London, 1916), p. 100, the author mentions visiting Lanckoronski in Vienna (this notice brought to my attention by Professor Miziolek, written communication, 1999).

262. Marandel (note 260), p. 72, mentions their existence, while their probable destruction is recorded by Dr. Ciechanowiecki (letter to author, October 29, 1999).

263. Davies (note 247), p. 351.

264. Mention was made of a "Saint Paul" by Masaccio belonging to Bayersdorfer in Cornelius de Fabriczy, "Recherches nouvelles sur Donatello, Masaccio et Vellano," *Gazette des Beaux-Arts*, series 3, 8 (October 1892), p. 329, n. 1, where the author tentatively describes the painting as having originally formed part of the Pisa Altarpiece. On Bayersdorfer, see Siegfried Käss, *Der heimliche Kaiser der Kunst: Adolf Bayersdorfer, seine Freunde und seine Zeit* (Munich, 1987), which is largely based on a trove of about two thousand letters inherited by the author's wife, Bayersdorfer's granddaughter, to whom I am greatly obliged for a copy of this book.

265. Jerzy Miziolek, "The Lanckoronski Collection in Poland," *Antichità viva* 34, no. 3 (1995), p. 42, n. 31.

266. Author's translation. Professor Karl Hillebrand, as quoted in a letter from John de Sohres to Bayersdorfer, 1881 (Käss [note 264], p. 123). This assessment was repeated in Adolfo Venturi's obituary of Bayersdorfer in *L'Arte* 4 (1901),

p. 75. Käss devotes a chapter to Lanckoronski, whose correspondence with Bayersdorfer amounts to eighty-two letters. Those from the art historian August Schmarsow amount to seventy-two (Käss [note 264], p. 190, n. 4).

267. Käss (note 264), p. 194.

268. Regarding Bayersdorfer's role as adviser to Count Lanckoronski and his gift of the Masaccio, Andrew Ciechanowiecki has written: "I have also been told [by Karolina Lanckoronska] that the Masaccio was a gift from the dealer who supplied Lanckoronski with early Italian paintings (Bayersdorfer?). Prof. Wilde would probably not make a mistake in such an important matter and as Lanckoronski was such a good client of Bayersdorfer it is not astonishing that the latter might give him this valuable gift" (letter to author, October 29, 1999).

269. For the later history of the Lanckoronski collection, see Miziolek (note 265), pp. 31–33, and Marandel (note 260), pp. 72–75. On its confiscation by the Nazis, see Charles de Jaeger, *The Linz File: Hitler's Plunder of Europe's Art* (London, 1981), p. 50.

270. Correspondence between Andrew Ciechanowiecki and Burton B. Fredericksen, then Curator of Paintings at the Getty Museum, regarding the latter's purchase of the painting is preserved among the Heim Gallery Papers in the Resource Collections of the Getty Research Institute, Los Angeles.

271. Wilhelm E. Suida, "L'Altare di Masaccio già nel Carmine a Pisa," *L'Arte* 9 (1906), pp. 125–127.

272. Suida (note 271), p. 126, n. 1.

273. Adolfo Venturi, *Storia dell'arte italiana*, vol. 7, pt. 1 (Milan, 1911), pp. 116–118.

274. For a detailed account of the acquisition, see the exemplary discussion in Leone de Castris (note 90), pp. 66–68.

275. Detlev von Hadeln, "Andrea di Giusto und das dritte Predellenstück vom pisanischen Altarwerk des Masaccio," *Monatshefte für Kunstwissenschaft* 1 (1908), pp. 784–789.

276. See Hannelore Nützmann, "Ein Berufsleben: Frida Schottmüller," *Mitteilungen des Kunsthistorischen Institutes in Florenz* 40 (1996), pp. 237–238. For the conventional account of the predella's acquisition, see Crowe and Cavalcaselle (note 222), p. 60, n. 1 (editors' note by Douglas and De Nicola).

**FOLDOUT**

Masaccio, *The Pisa Altarpiece*. Photographic assembly and key illustrating author's hypothetical reconstruction of altarpiece as configured in 1426.

# ACKNOWLEDGMENTS

I gratefully acknowledge the expertise and support of the staff of the J. Paul Getty Museum, past and present, in the timely completion of this book. It was the former Curator of Paintings, David A. Jaffé, who championed my proposal, and the editorial staff at Getty Publications—particularly Mark Greenberg, Editor in Chief; Mollie Holtman; and Tobi Kaplan—who, along with Diane Mark-Walker and Brandi Franzman, were key in seeing it to fruition. I am also grateful to Scott Schaefer, Curator of Paintings, and Dawson Carr, Associate Curator. Jeffrey Cohen provided the book's handsome design. And Carol Togneri, as ever, was a source of encouragement and many important leads.

Many thanks are due to Rolf Bagemihl for bibliographical material and for transcribing the will of Masaccio's patron, Ser Giuliano degli Scarsi. Francesco Quinterio kindly examined Santa Maria del Carmine, Pisa, and provided crucial data pertaining to Ser Giuliano's long-lost chapel there. For information on the Lanckoronski collection I am grateful to Andrew Ciechanowiecki, J. Patrice Marandel, and Jerzy Miziolek. Nicholas Penny generously shared his ongoing research on Samuel Woodburn, as did Jaynie Anderson on the subject of Giovanni Morelli. I owe a particular debt to Dillian Gordon, who read the manuscript, making many crucial suggestions, and who generously lent me the entry on Masaccio from her forthcoming catalogue of the fifteenth-century Italian paintings at the National Gallery, London. I was particularly fortunate with the choice of outside readers: Andrew Ladis, who offered several improvements, and Larry Kanter, who aided me greatly in the matter of the altarpiece's original appearance. Finally, the text was greatly improved thanks to the editorial skills and good sense of Martin Eidelberg.

For all manner of assistance I wish to thank Joseph Baillio, Martin Braid, David Alan Brown, Virginia Budny, Frank Dabell, Terrie Di Gangi, Everett Fahy, Burton B. Fredericksen, Mario Giannini, Ay-Whang Hsia, Donata Levi, Marcos Lopez, Greg Muenzen, Carl Brandon Strehlke, Cornelia Syre, and Gianluca Tornem, as well as the staffs of the Frick Art Reference Library, the New York Public Library, the Kunsthistorisches Institut in Florence, and the Harvard University Center for Italian Renaissance Studies at Villa I Tatti, Florence.